*In Retrospect*

# DURSLEY

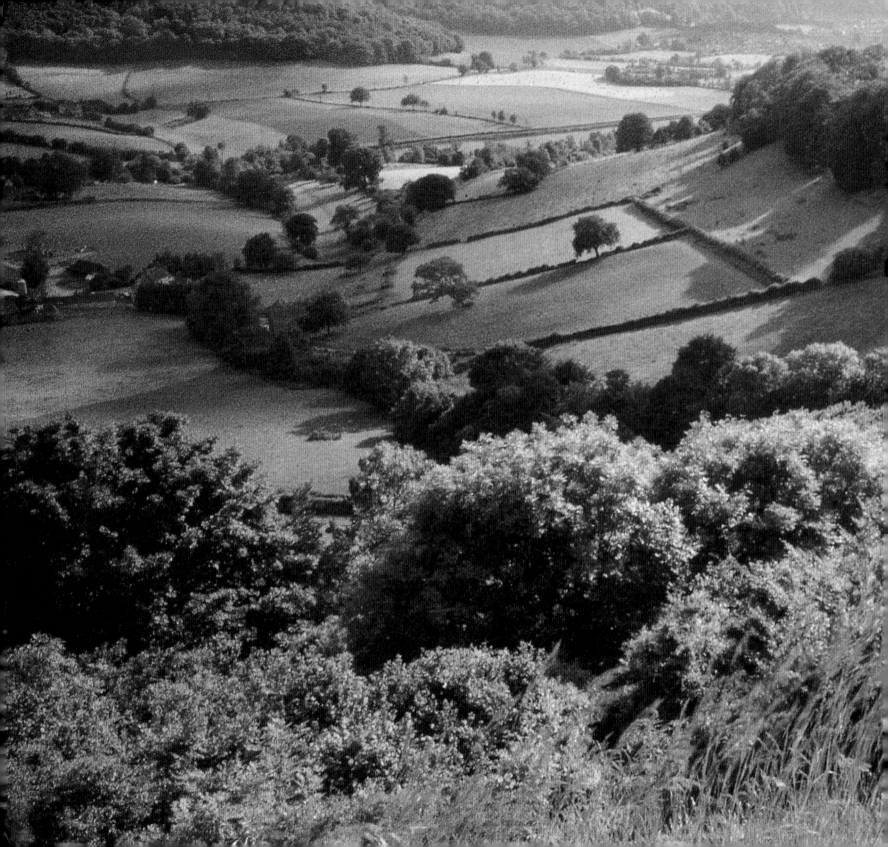

*In Retrospect*

# DURSLEY

### COMPILED BY ALAN SUTTON

### COLOUR PHOTOGRAPHY BY TONY GLOSTER

For my Father,
a Dursleyan

First Published 1999
Copyright © Alan Sutton, 1999

Tempus Publishing Limited
The Mill, Brimscombe Port,
Stroud, Gloucestershire, GL5 2QG

ISBN 0 7524 1672 3

Typesetting and origination by
Tempus Publishing Limited
Printed in Great Britain by
Midway Clark Printing, Wiltshire

# INTRODUCTION

This book is unashamedly an indulgence, an enjoyment. It is an opportunity to display some of my favourite photographs of Dursley and its surroundings. In this publishing indulgence I have had the good fortune of working with Tony Gloster and his photography adds to and embellishes my selection of black and white images. For my own selection I have attempted to choose originals of high quality that provide pictures of interest covering the last century. Tony's photographs are a contrast to this historical evocation and are a reminder of the great beauty that surrounds us.

I now spend most of my time away from England and this exile gives cause for reflection on my home town and my ancestry. This book is the result of these reflections from foreign shores – a simple retrospect on Dursley through the twentieth century with the colour images providing the end-of-century snapshot and, dare one say it, the apotheosis to the sylvan beauty that envelops the town.

My interest in my own home town combines with my love

of history. My reflections from foreign shores led me to question how my family came to live in this beautiful area and to muse on the vicissitudes experienced by my ancestors as generation followed generation. In this book I have taken the liberty of including family photographs as an example of a typical family in a typical community. My paternal grandmother, Louisa, came from an old Dursley family and undoubtedly had deep roots in the town. My grandfather, Joe, walked from Birmingham to live with his uncle, David Sutton, at Rockstowes in 1895. He did this walk quite frequently, sleeping under hedges, and the first time was when he was just fifteen years old. But what was it that brought his uncle to the area? This was a question that was only answered to me three years ago when visiting my cousin Arthur in Pennsylvania. David was Arthur's grandfather and, late one evening, sat on his lakeside veranda overlooking the beautiful Poconos Mountains, Arthur narrated the family history and the reason for him leaving for America back in 1925. It was wonderful: memories of life in Dursley during the First World War, pickled in Cotswold aspic unpolluted by clouded memories of subsequent events. I say unpolluted, because having left the town he could not have muddled memories of later years he was not able to witness.

David worked in an iron foundry in Birmingham, along with the other menfolk of the family. The work was hard and hot, casting huge chain links for the glory of the Royal Navy. The upshot of the hard, hot work was refreshment in beer, with drunkenness a frequent result. David married a girl in service to a local family, and to escape the beer she brought David to her home area. Not quite to her village, for she came from North Nibley, but close enough to have roots to

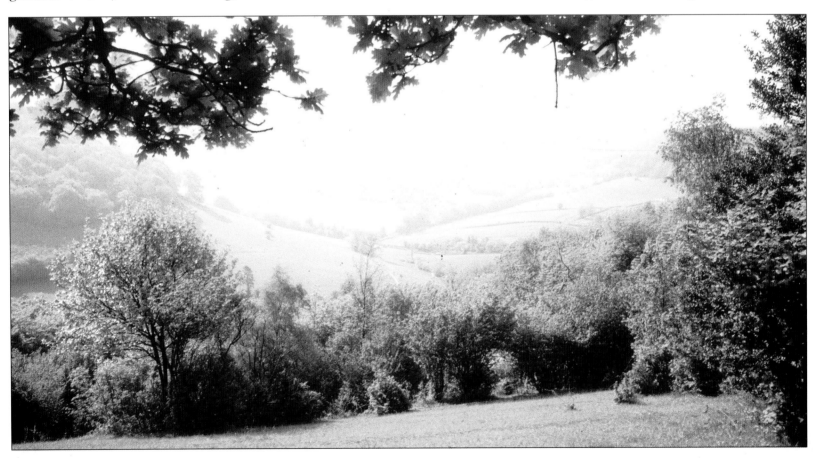

take up. David took up a trade associated with foundry work – the manufacture of foundrymen's asbestos gloves – and set up his manufactory next to the cottage on the Uley Road. Joseph, my grandfather, was also a foundryman in Birmingham. He came to live with his uncle and eventually married Louisa Hancock on Christmas Day 1903. He worked in the foundry for Ashton Lister and retired in 1945. From what I have learned and from what Arthur has told me I am tempted one day to produce a book, but this is not the right occasion. I have three hours of tape recordings from Arthur, so one day, when I have time …

I attended at Lister's from when I was sixteen in 1965 until 1968. I say attended, for in all honesty I cannot say I did much work. How the circumstance came about I do not know, but in December 1965 I was summoned to the 'shed', the office of the manager in the cost office. There I was told, "Sutton, Mr Robert [Lister] has instructed me to tell you that you are to call at the [Lister] Club each Friday after work. There, Mr Cook will give you two ounces of tobacco that you are to take to your grandfather." The age of patronage in this sense has gone, but I feel that I witnessed its last vestiges.

When planning this book over the past two years I was tempted to subtitle it *Landscape and Community*, but eventually changed my mind, as I wanted to produce something simple and unpretentious. My original notion of the content has remained unchanged and it is simply Dursley through this century, with a typical working-class family – my family as an example of community. I do not intend this to be a history in any sense. It is simply a selection of black and white and colour photographs.

I played around with the title. Was it going to be *Around Uley, Dursley and Cam*, or was it to be *Cam and Dursley*? In the end I have gone for simplicity and just called it *Dursley*. I am sorry if I upset sensibilities, for that is not my intention.

I have said that it is not intended to be a history, for in such a short book that would not be possible to do with any sense of justice to the locality. Having said that, I could not resist the temptation to include one or two minor nuggets of information. My anecdotes and captioning are a mixture of childhood memories, information and opinion – eclectic thought and idiosyncratic presentation – very much a personal view.

It could be said to be a celebration of this amazing century of change as we reach the millennium; I certainly like to think of it as such. The second half of the century I have known, the first half I know of through my family. The changes have been staggering: the last fifty years alone have seen the transition from a lively market town to a dormitory community. The town is rapidly changing, the days of manufacturing and local shopping have almost gone. We all wish we could reverse this trend but the power of our social revolution is stronger than our will and good intentions can cope with. Two centuries ago we had apothecaries; throughout my life these have been called chemists. Now we seem to have pharmacies. In my youth we had several tailors and at least two jewellers in the town but now we have none. I will not dwell on our changing society and can only hope that this small contribution to our past will remind us of those simpler days. In my vanity I also hope it will provide an entertaining pictorial record for the posterity of our local community.

Alan Sutton
Hydefield, Uley

May 1999

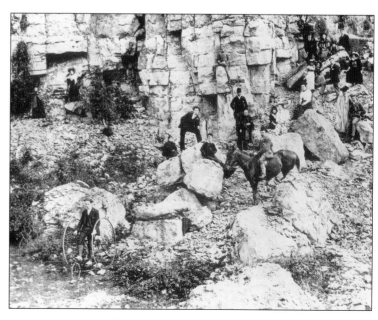

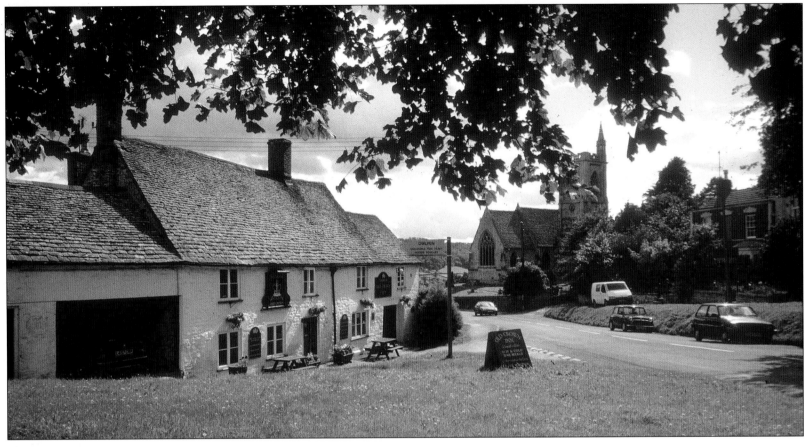

# THE BEGINNING

As with my 1991 book, *Uley, Dursley and Cam*, I am presenting the book as a route, starting at the Top Crown in Uley. The pub's real name is the Old Crown, but it has always been known as the Top Crown simply because until the late 1960s there was another Crown in Uley. The view to the right shows a bus outside the pub in the late 1930s.

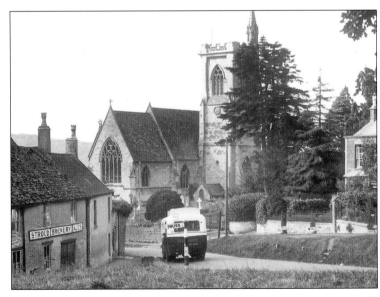

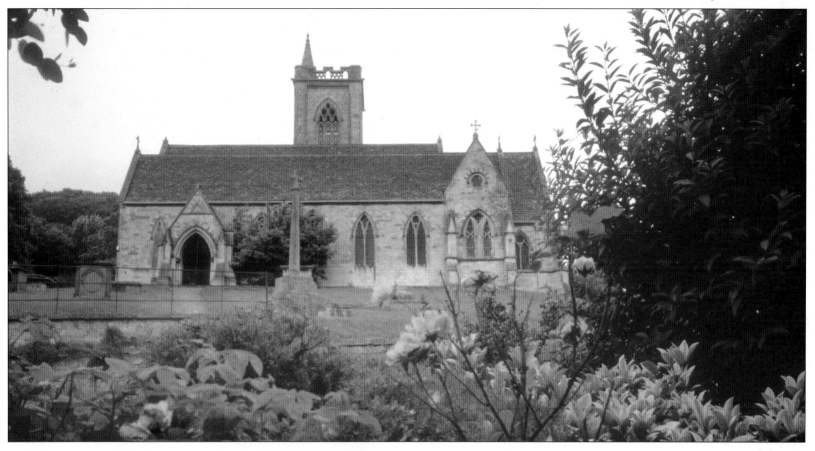

Uley church was built in 1858 on the site of the medieval church that had apparently fallen into very poor condition. The Victorians were great church builders and it is with some irony that some Victorian churches are now being abandoned in favour of medieval churches that they ostensibly replaced, as is the case at Didmarton, which, unlike Uley, had a medieval church that was not demolished. Each generation has different sets of values, and to the Victorians Uley church had reached its sell-by date. Had it survived, we might now be calling it a little gem with a fine, low Norman tower.

Two views of the Street, fifty years apart. The lack of traffic in the early photographs is a reminder of simpler days when the expression 'traffic calming' would have been considered a very strange use of English. Perhaps one way of calming would be to go back to the condition of the roads in the Street in the middle of the nineteenth century. Apparently, at that time there was only one set of ruts up through the village and everyone with a wheeled vehicle tried to keep to it. If two vehicles met there was great difficulty in passing as in some places the ruts could be up to a foot deep.

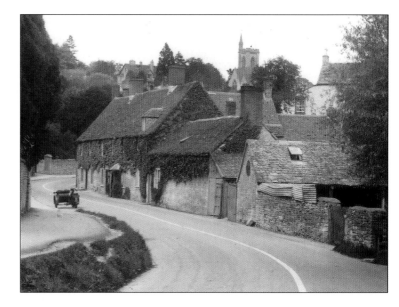

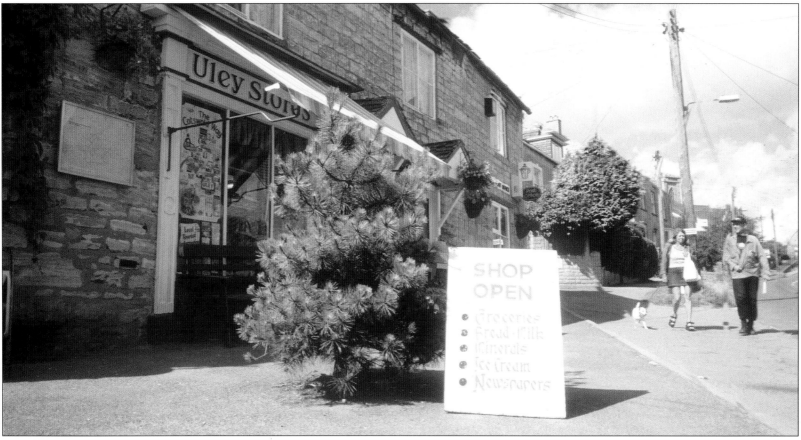

The turnpike house is long gone and this photograph is a reminder of how we now take our road infrastructure for granted. The house was built around 1790 when the new turnpike road was made and the gates were removed about a century after that. The area to the left was the wash-pool for sheep, the only reminder of this past usage being the building in front of the house, now used as a garage. In its original form it was associated with the wash-pool.

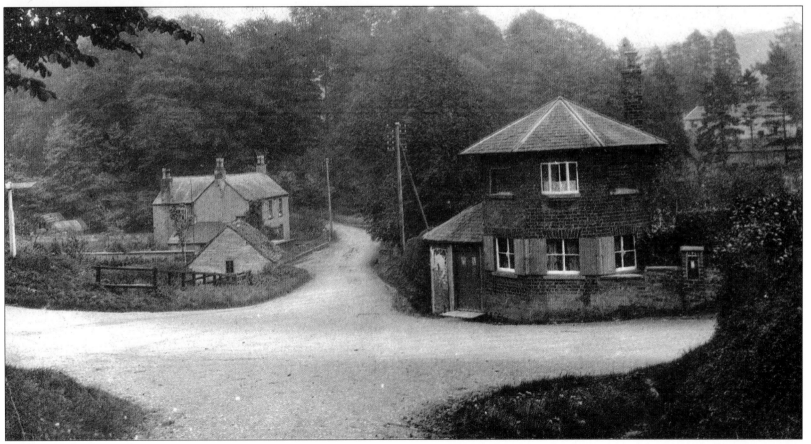

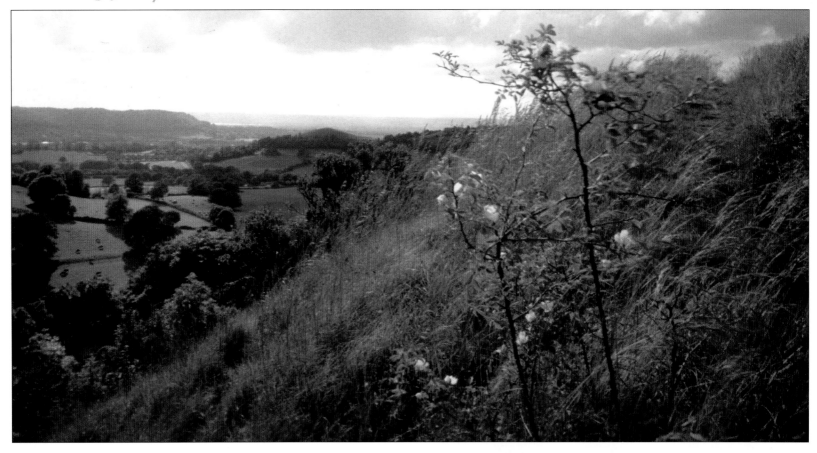

The dramatic landscape in our valleys is the result of frequent ice ages, the last of which was as recent as 12,000 years ago. The retreating glaciers slid down towards the Severn carving out the weaker rocks, leaving the outlying hills of Smallpox Hill, Cam Peak and Long Down in their current shapes. The top photograph is taken from Uley Bury, a major Iron Age hill fort that even now, almost 2,500 years after it was first shaped with surrounding ditch and vallum, is awe-inspiring in its scale. Standing in the ditch looking up at the vallum I try to imagine what it was like before erosion diminished its scale and how it would have looked surrounded by timber palisades.

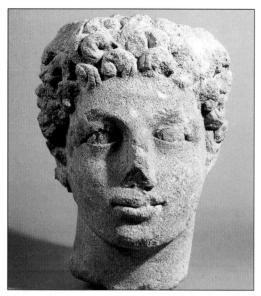

The excavations of the religious complex at West Hill, Uley, between 1976 and 1979, resulted in 8,000 small finds and 67,000 sherds of pottery. One of the most dramatic finds was this stone head. The shrine was almost certainly centred around a cult of the god Mercury. The site was extensive and the temple was substantial – obviously attracting Romano-British citizens for some distance around. The site had Iron Age origins and was later rebuilt as a Roman temple. The temple was destroyed in the fifth century, but later buildings on the site existed into the eighth century and may have been associated with early Christianity.

It was assumed that this photograph was taken in Lampern Quarry, but I now have some doubts. I believe it may have been in the quarry in Coaley woods. I shall go and take a look soon to satisfy myself on this point and trust that the disused quarry

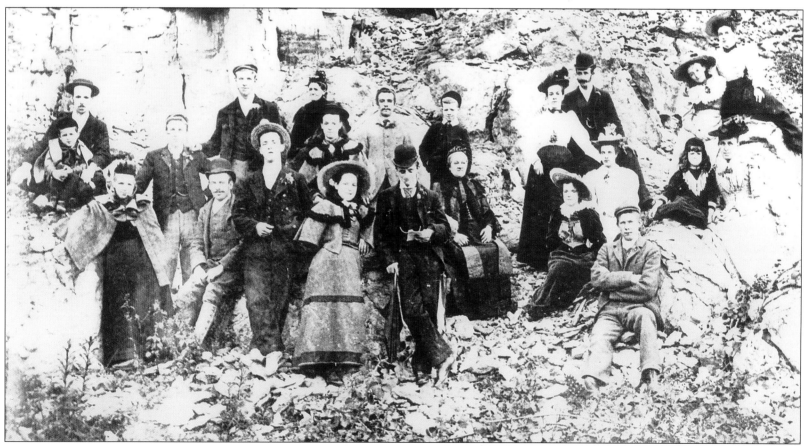

will not have changed too much. I am told there are family members in the photograph but unfortunately I have no identification. Nevertheless, it is a splendidly posed picture. The photographer had artistic aspirations and was practising his photography in the relatively early days of this new visual medium, probably *c.*1885. The photograph on page 7 was taken on the same day in the same location.

*Left:*

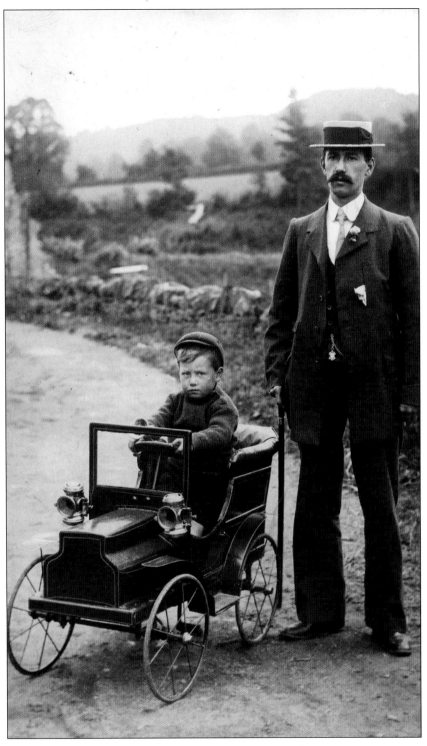

My great-uncle, Archie Sutton, with Arthur at Rockstowes. Arthur was born in 1906, so this photograph is probably around 1911. Archie was a talented engineer and worked for Gardiners at what is now the Dursley Garage. In later life he worked at Lister's. He was clever with his hands and among many other things he made this car for Arthur. This photograph was among the belongings Arthur took with him to America in 1925. On his death in 1997 he left me all of his family photographs and they are now safely returned to Dursley.

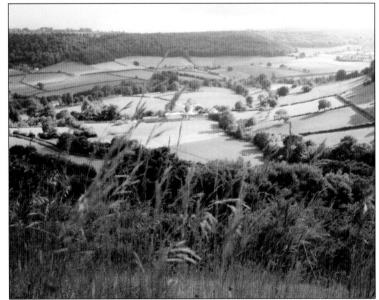

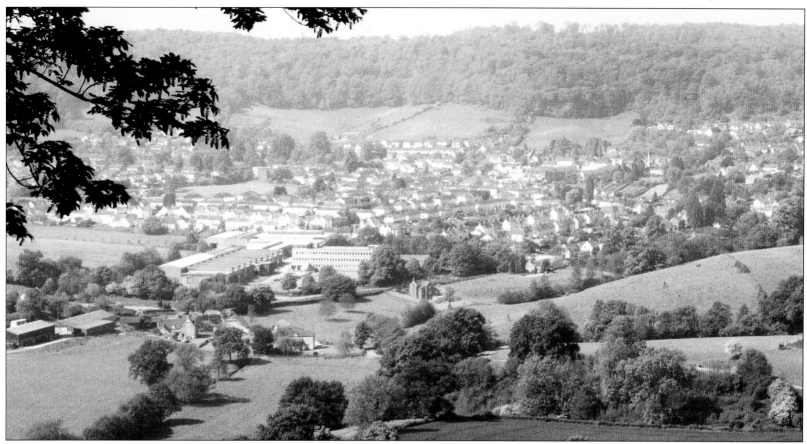

The view from Smallpox Hill looking across the Uley Road and Woodmancote towards the beech-wood cloak that surrounds the town. From left to right the woods are Folly Wood, Dursley Wood and Hermitage Wood.

Smallpox Hill was originally named Warren Hill from the medieval rabbit warrens that were built into the north side of the hill and of which impressive remains may still be seen. This was the source of food for the medieval lords in winter. For some reason the Ordnance Survey took it upon itself to name it Downham Hill. Locally it is known as Smallpox Hill from the fact that up to the nineteenth century it housed an ancient tower-like cottage on the south-eastern side, close to the summit, used as an isolation 'pest house' for smallpox victims. The cottage was still standing in 1877 and was finally demolished early this century.

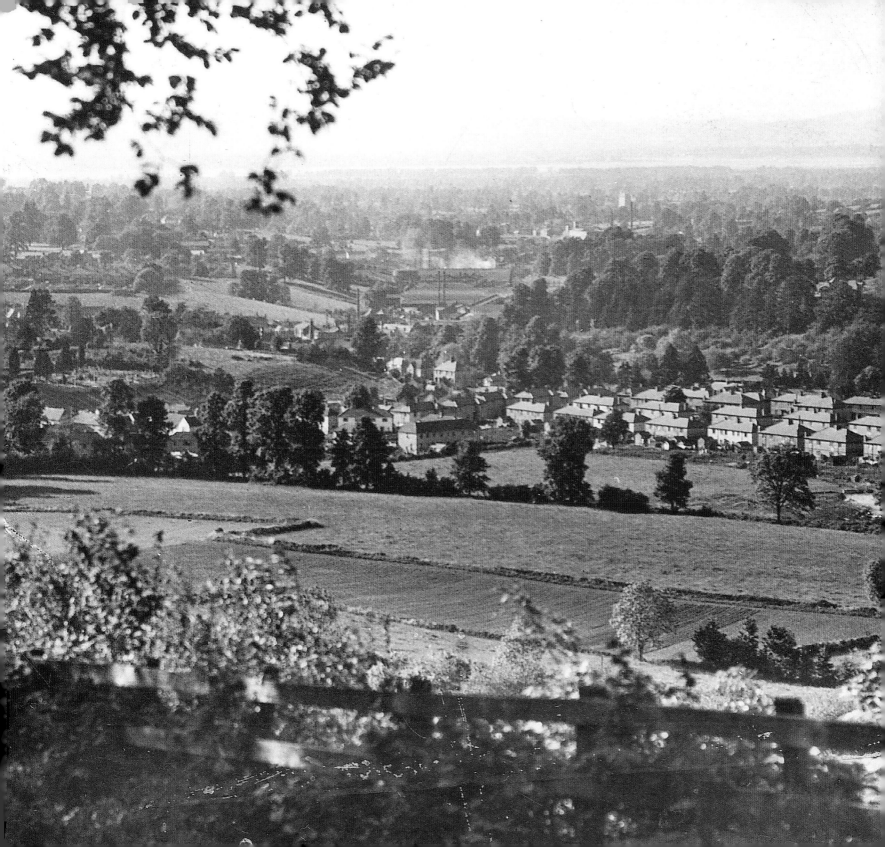

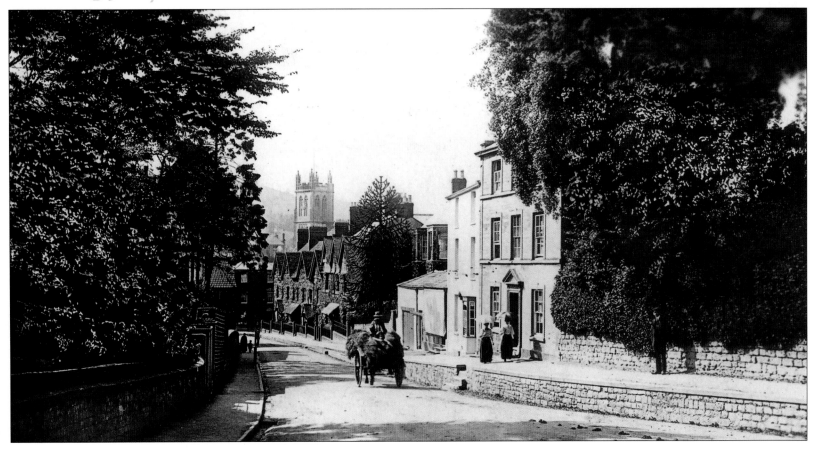

The view on the previous two pages was taken around 1947 and looks across Dursley to the Cam Valley, with the R.A. Lister factory prominent. Note the lack of bricks and mortar in the fields, now planted with houses.

The top photograph on this page shows Bull Pitch in 1907. Bull Pitch was named after the pub, the Bull, which is shown in the view to the right, third house from the left, now a private residence. It ceased to be a pub in the early 1940s.

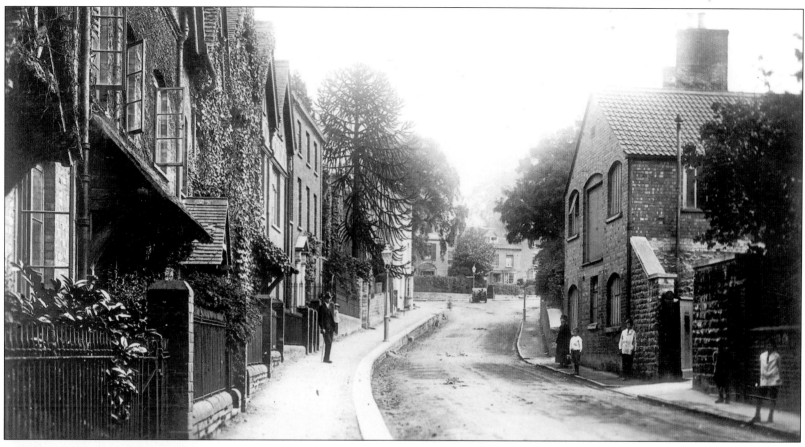

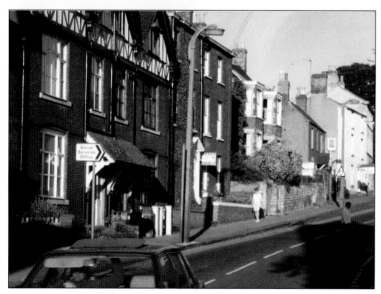

Looking up Bull Pitch, a view from the beginning of the century with the splendid Chile Pine – the Monkey Puzzle tree on the left hand side. I cannot recall when this was felled, but remember it as a child in the 1950s when it made a great impression on a young mind.

*Below*:

A view from the church tower, *c.* 1905. This picture is taken from a collotype postcard rather than a real photograph and is therefore not as good an image as other photographs. I have included it in the book because of its interest. The building on the bottom left-hand side is the Old Forge, now the 3rd Dursley Scout headquarters. The Union Workhouse is just visible at the top right of the image. There is a good view of the brewery and the drill hall, once a Non-Conformist chapel. This is visible in the absolute centre. Hill View, my grandparents' house with extensive gardens, is just about visible in the area below the workhouse leading down to Union Street.

*Right*:

A startling contrast pulls us back to the end of the twentieth century: children roller-blading in the Slade.

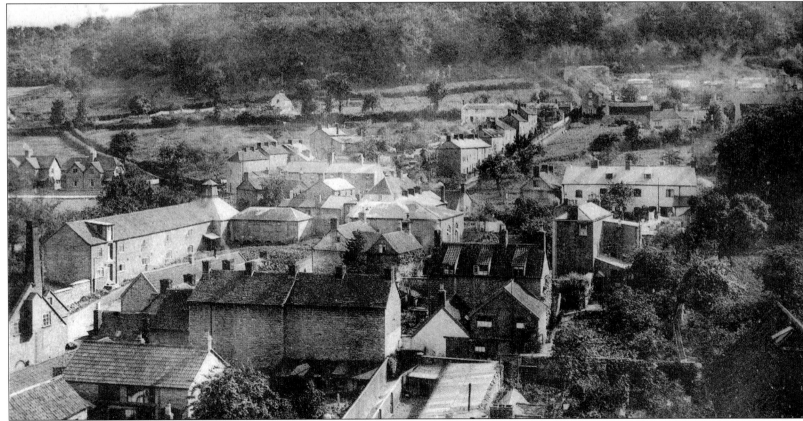

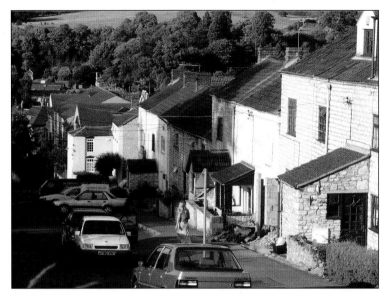

Contrasting views in Union Street. For those not familiar with how the street looked it will be difficult to find your bearings other than to focus on the early nineteenth-century stone cottages still remaining. The Cross Keys is exposed to view by the demolition of the cottage at the old crossroads. The brewery has gone, replaced by Champions Court. The old photograph shows how the street remained until the late 1960s.

The cottage on the far left is Hill View, my grandparents' house, the site of which is now covered by Sutton Close.

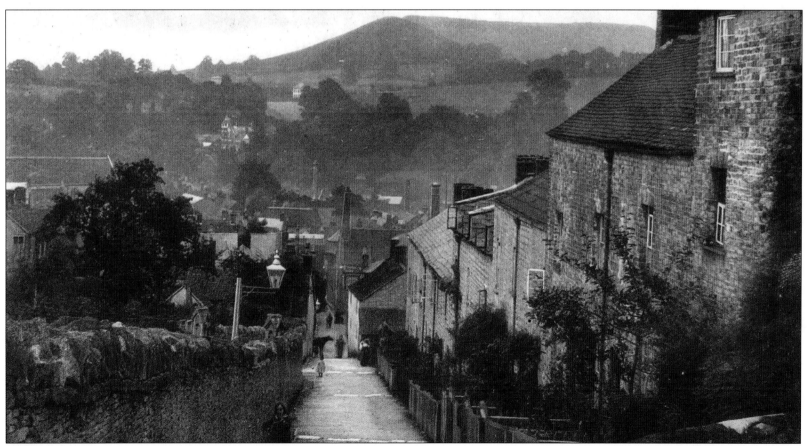

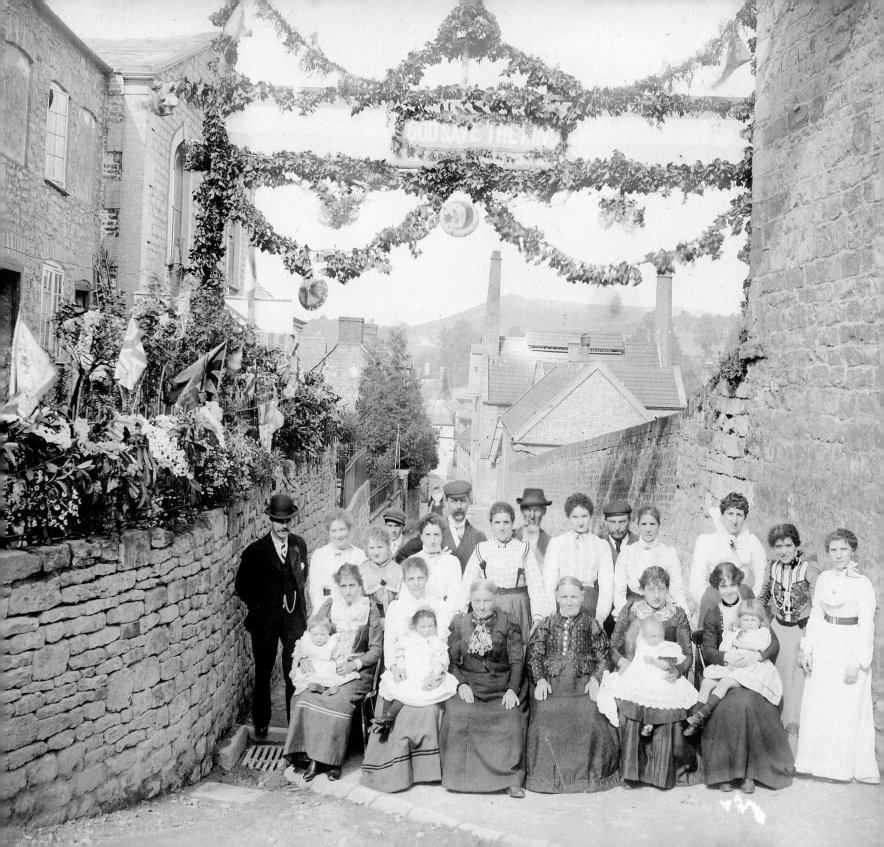

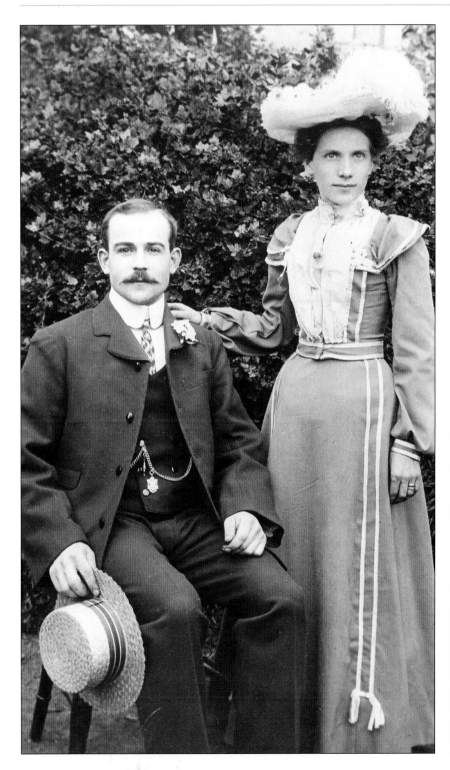

*Far Left*:

The Boulton Lane Celebration Committee, 1902. Edward VII wanted his coronation to be an occasion for national rejoicing, and in order that it should not be overshadowed by the Boer War, was not scheduled until the end was in sight. 26 June was the date chosen. On 14 June the king was taken ill with appendicitis and the coronation was postponed while he fought for his life.

Ellen Hancock is in the left-hand half of the photograph in front of the gentleman with a flat cap and splendid moustache. Ellen was to marry Archie Sutton and become the mother of Arthur. Her sister, Louisa, is on the far right. She was to marry Joseph. The left-hand old lady in black was Betsy Cross, Louisa and Ellen's grandmother, my great-great-grandmother. She was born Elizabeth Elliot in 1836 and married Thomas Cross in 1858. She could not write and on her marriage certificate she signed by making her mark.

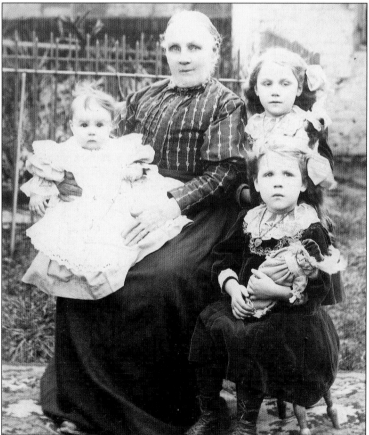

*Previous page left*:

My grandparents, Joseph and Louisa, on their wedding day, Christmas Day 1903.

*Previous page right*:

Betsy Cross at the back of Rose Cottage in Boulton Lane with three of my aunts. The baby is Queenie Winifred May, standing is Mabel Emmie and seated with the doll is Elizabeth Poppy. Elizabeth (Bessy) died of diphtheria just a few weeks after this photograph was taken. This was one of the family photographs taken by Arthur to America. His poignant narration eighty years after the event was very moving for me. Mabel and Bessy were his cousins and playmates.

*This page*:

Two views of the Slade showing the alteration of vista by the removal of old cottages. The right-hand photograph was taken in 1956 shortly before the cottages were demolished. They were said to be slums, but if the will had been there they could have been saved and remodelled. Their demolition was an early phase in a proposed relief road that was later abandoned.

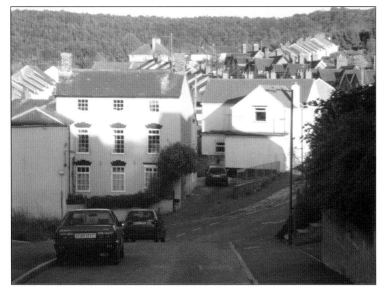

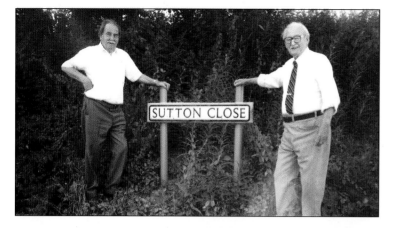

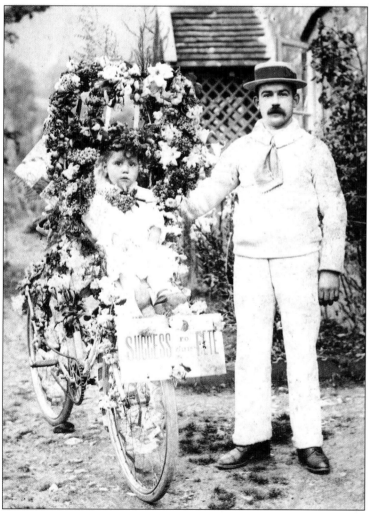

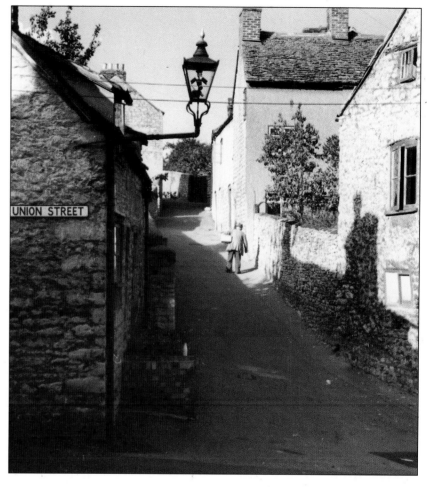

*Top left*:

A snapshot of my father, Archie Sutton, and his cousin Arthur by the sign of Sutton Close shortly after the Close was built. My father is named after Arthur's father.

*Left*:

Joe with Mabel outside Hill View, *c.*1912. This site is now Sutton Close.

*Above*:

The Slade at the crossroads with Boulton Lane and Union Street in 1956. Walking up the hill is my grandfather, Joe Sutton. After his retirement from Lister's he worked as caretaker at the drill hall.

*Left*:

Walking the dog on the grassland adjacent to the Slade, once the extensive kitchen gardens of the Union Workhouse and probably soon to become a building site.

*Below*:

An impressive view of the Union Workhouse from a collotype postcard with Hunger Hill in the centre of the picture. The Workhouse remained a prominent feature of Dursley for just over one century. Perched on the hill, it was a constant reminder to the more vulnerable classes of the Victorian notion of a safety net.

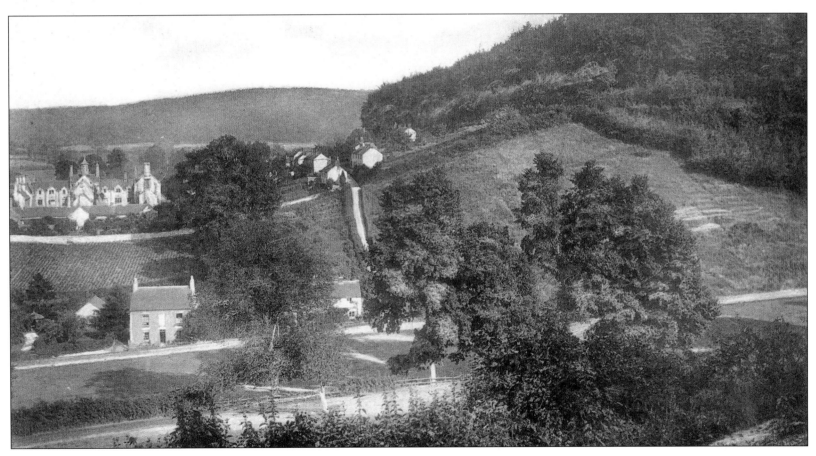

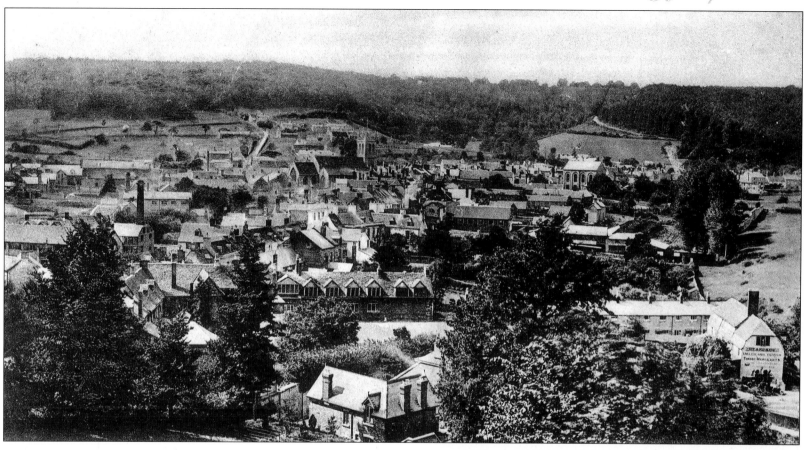

*Above*:

A view from the Towers, probably taken in 1897 when the Towers was being built. This is an impressive view with much historical interest, and although only a collotype reproduction, still worthy of inclusion. It clearly shows Edward Gazards workshops, occupied in 1897 by J. Peake & Co., timber merchants. This was demolished in 1903 and replaced by Lister's Churn Works, destroyed by fire in 1983. Other points of interest include the Pump Field behind the workshops, separated by just one gate from the remainder of Castle Farm. Ashton Lister's original factory is shown towards the left, the mill with the chimney stack.

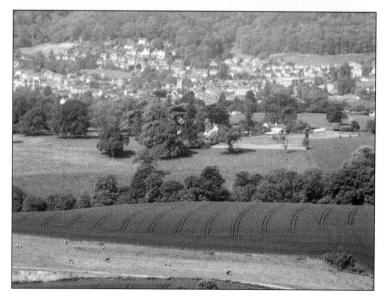

Three views at the Broadwell. The sheltered valley with a good water supply must have been a great attraction and there is little doubt that Dursley has been a settlement for some thousands of years. A Roman villa stood at Chestal, just 250 metres from the Broadwell and there were doubtless other settlers before the Romanized Britons.

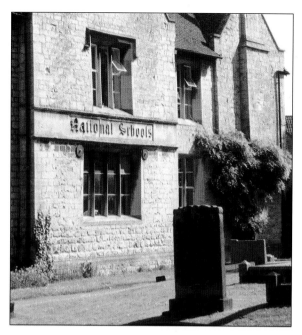

The church, the church school and a glimpse towards the Broadwell. The church tower, although in the Perpendicular style, is relatively modern, having been completed in 1709. The previous tower had a steeple which Daniel Defoe, the author of *Robinson Crusoe*, referred to 'as an handsome spire'. Over-exuberant exercise cost the bell-ringers dearly, for the tower and steeple collapsed in January 1699 while the bells were being rung, with the loss of several lives. The tower was built in traditional fashion by Thomas Sumsion of Colerne in Wiltshire and its design was based on Colerne church.

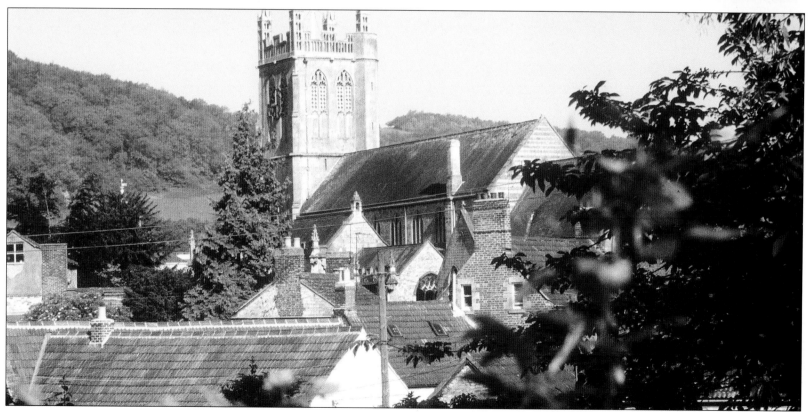

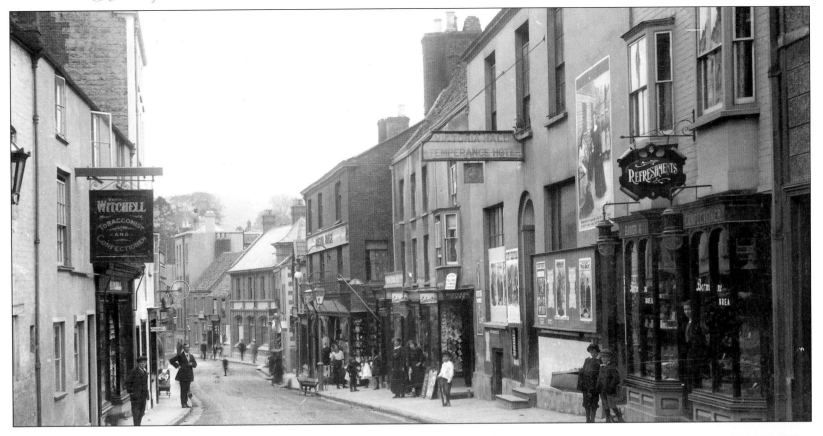

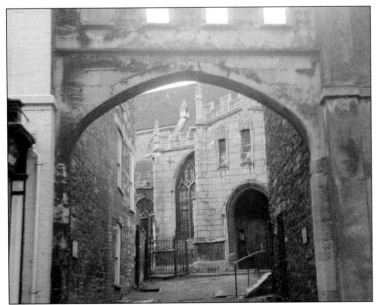

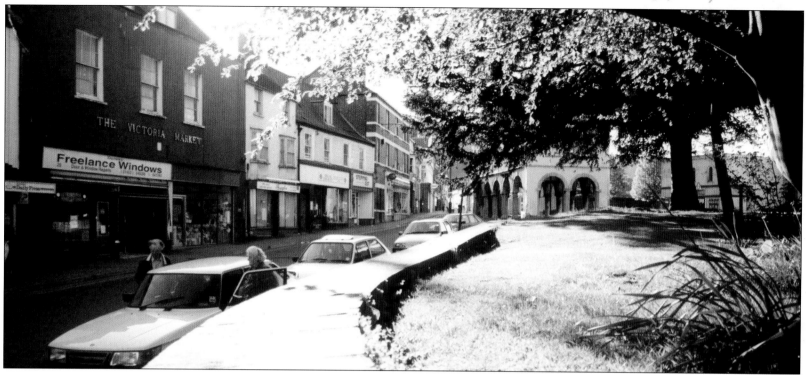

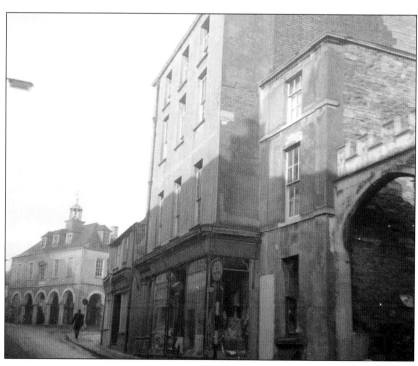

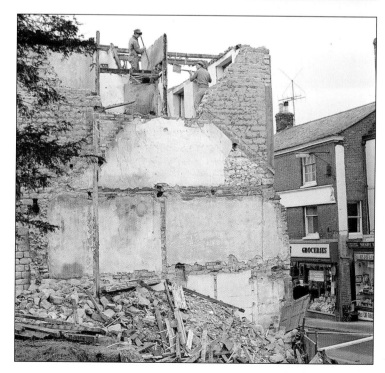

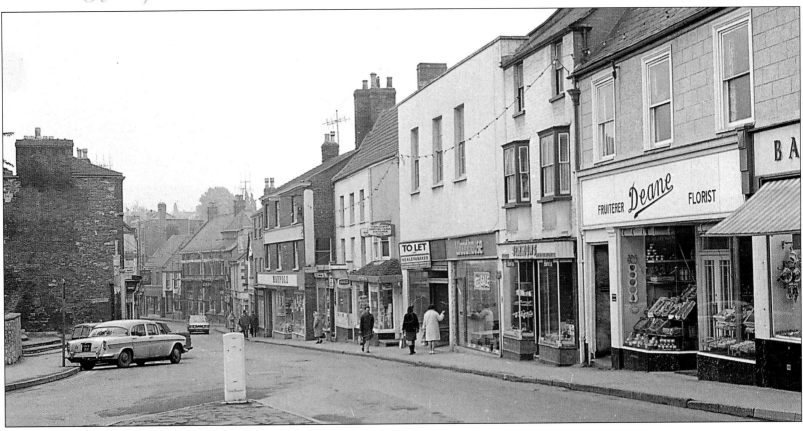

*Page 30:*

Silver Street during the first decade of the twentieth century. The Victoria Hall Temperance Hotel has just gone commercial, and become the town's first cinema. All of the buildings visible on the left-hand side of the street were to be demolished in the 1960s.

The distinctive archway over the steps leading to the church is shown in this amateur snapshot taken in January 1962. The colour picture shows the current view from the church porch – minus the crenellated arch.

*Page 31, top:*

Post-demolition Dursley. There are conflicting views between the open-spacers and the builders. I am a builder and believe that the open space is a mistake that ruins the townscape. There is an opportunity in Dursley to have some attractive buildings put back into the heart of the town and pump some life back into the community. Having said that, the space is useful for those citizens who wish to lounge on the church wall and swig lager.

*Page 31, bottom:*

Another snapshot view of Silver Street from January 1962. All of these buildings – with the obvious exception of the Market House – were scythed, sacrificed to progress. The last photograph was taken in late January 1962 – another one goes in the demolition process.

*Above:*

Silver Street in 1967. There is not much change from the view today for the buildings are essentially the same. Shop proprietors have come and gone and cars have gone to the scrap-yards. The 1960s were the first decade of post-demolition Dursley.

The destruction phase almost commenced with the demolition of the Market House in the name of progress and road safety. Thankfully, common sense prevailed and the building was spared. The Market House is one of the town's few saving graces and without it the street scenes would be decidedly sterile.

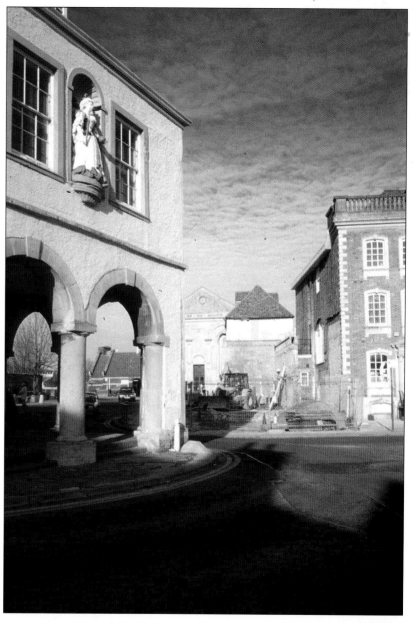

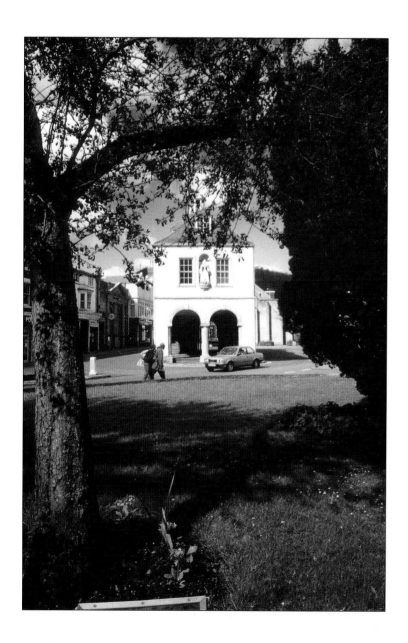

The demolition of Wilkes' may have been necessary but surely most of the footprint could be taken up with a new building? Having the Long Street frontage pushed back to allow large vehicles to pass is sensible, but apart from that the extra space is unnecessary.

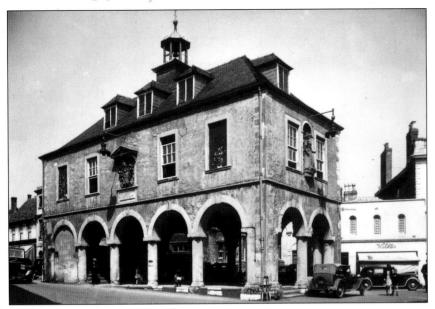

Two views of the market place, probably both just post-war. Behind the Market House can be seen the police station and magistrates' court, demolished in 1959. The resulting lane between these buildings and Wilkes' was The Knapp. This was the beginning of the lane leading past Castle Farm up the brow of the hill which may, at one time, have formed the outer part of the grounds covered by the castle. The name 'Knapp' is Saxon and comes from *cnæpp* meaning 'hill top'. This must therefore be an ancient part of the streets and alleys of Dursley: fourteen centuries of continuity swept away in our mad age.

The bottom picture, at the right-hand side, shows part of the buildings swept away to reveal the church and ease traffic.

It is unfortunate that the good citizens of Dursley should have suffered such destruction in the town without being given a coherent plan for the future. One reads the citizens'

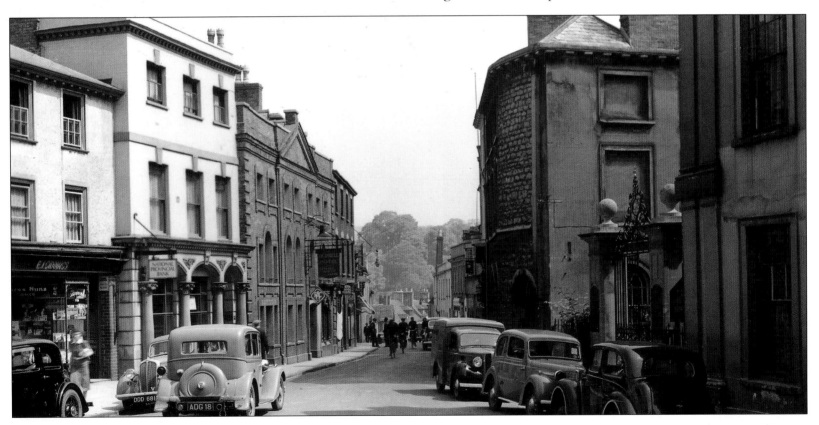

complaints all the time: ' "They" should do something about it.' ' "They" should bring some businesses back into the town' ' "They" should provide some jobs.' ' "They" should bring back proper butchers and bakers and candlestick makers, proper jewellers and a bookshop.' ' "They" should sort out the traffic.' ' "They" should . . . .' – I'm beginning to feel quite angry about this "They" that are letting the good burgesses down. Such great contributors with their constructive community spirit and hard work deserve better than this! I'm getting to feel really, really, hot under the collar about this terrible "They". Perhaps I should sit down and write a letter to the *Gazette*.

If there is any saving grace in street façades, it is that of the top of Long Street, for here we have some style, some feature and some pleasing proportions. Eagle House, the home of Lloyds TSB, is a splendid Georgian building. The Old Bell is distinctive, also with a fine eighteenth-century façade. Unfortunately the rest of the building is nothing very special, but never mind: the street frontage looks good.

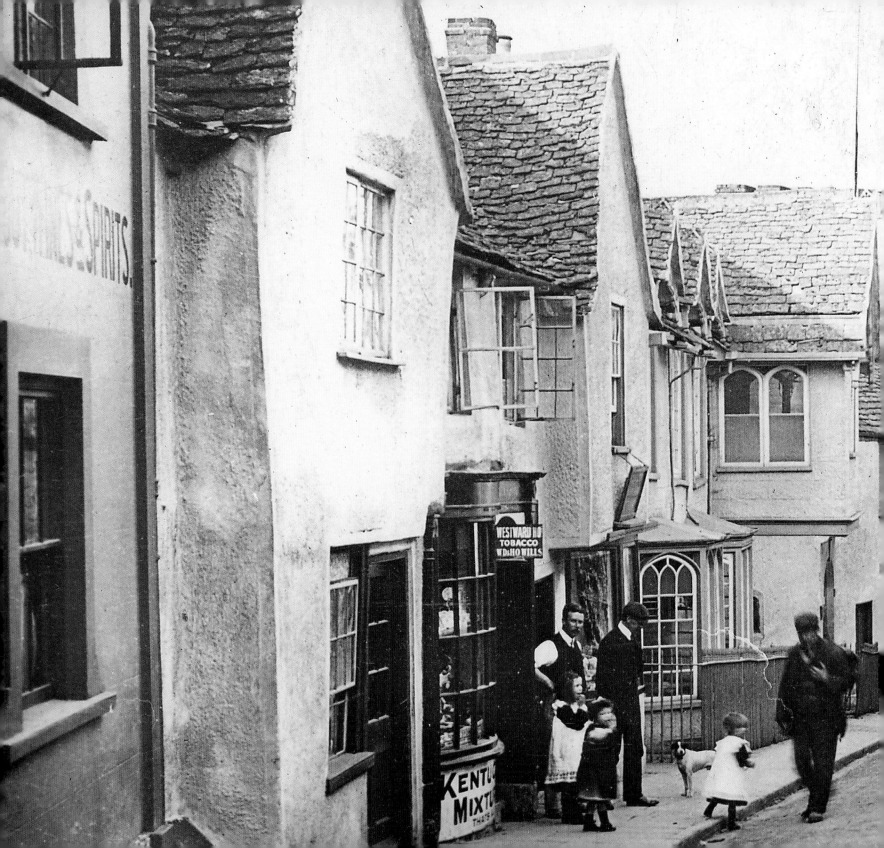

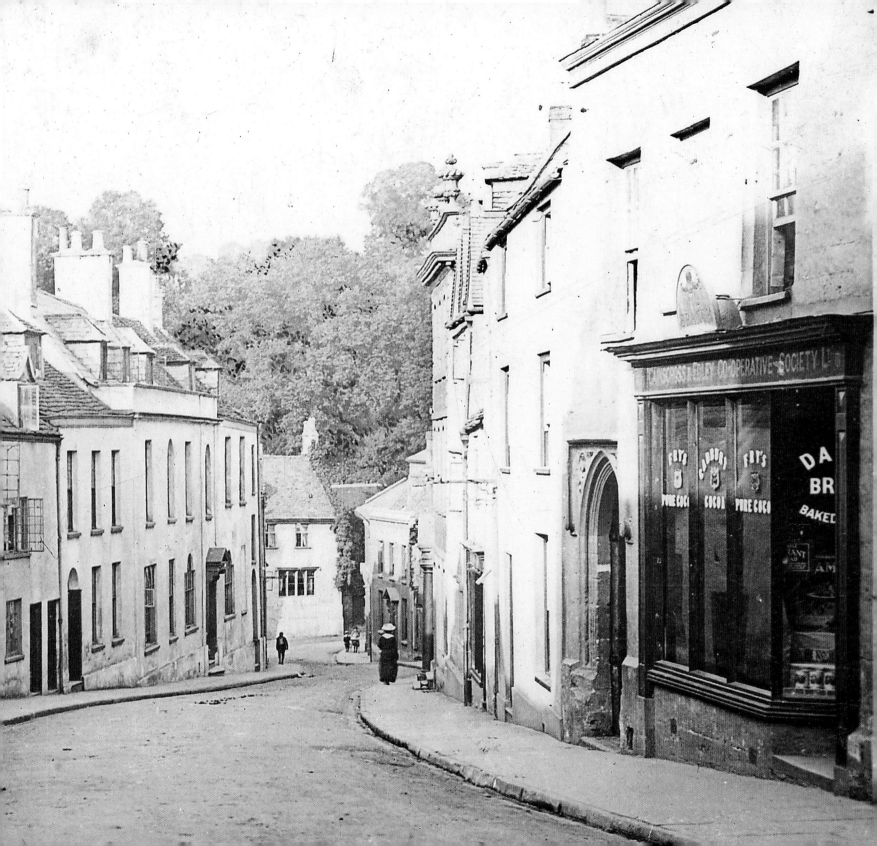

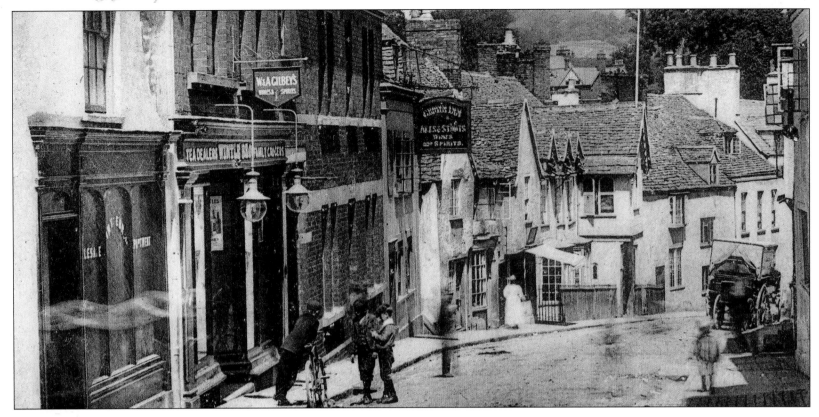

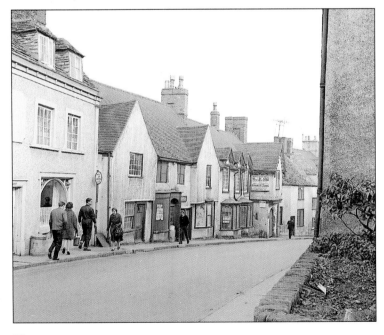

This group of photographs (pages 36, 37 and this page) shows the continuity of the street frontage that remained intact until 1965. At that time the old Champions carpet factory was bought by F. Bailey & Son for the site of their new newspaper printing works. The old works were no architectural asset and are no loss. Unfortunately, the distinctive group of frontage properties known as Blackwells Court were an impedance for access by large vehicles and were demolished. In fairness, they were probably in a very bad state of repair, but nevertheless they could and should have been saved. Attitudes are different now from those of the 1960s and it is unfair to criticize. Perhaps it should be just a sigh of sadness for what the town might have been. The 1960s were when we had shaken off the effects of the war and were looking towards a post-empire Britain. Everything had to be new, and in the shake-up much of our townscape heritage was sacrificed. The bottom left photograph on this page was taken very shortly before demolition with for sale signs clearly prominent.

In 1982 an application was put in to demolish numbers 57 and 59 Long Street and although it was almost a case of shutting the stable door after the horse has bolted, there was resistance to the application and the defenders won the day. Neither is of huge architectural merit, but they are pleasing and worth retaining in the street scene. It would be nice to think that some day the frontage might be closed back up (retaining suitable access), with the new façade echoing Blackwells Court. Who knows, views have changed considerably in this past thirty-five years, and in another thirty-five, street scene and sensible in-fill of these gaps may come to the top of the agenda.

The top picture on this page shows the new gap as it was in 1967.

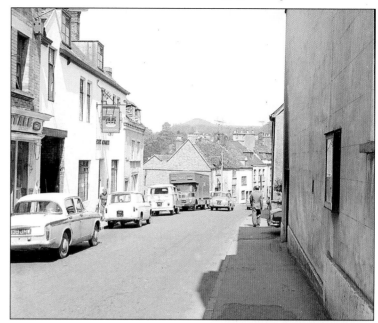

Most newcomers to the town, or anyone under the age of thirty-five, will find it difficult to believe there was ever a railway station in Dursley. Dr Beeching axed Dursley station and the last passenger train steamed out on 10 September 1962. The

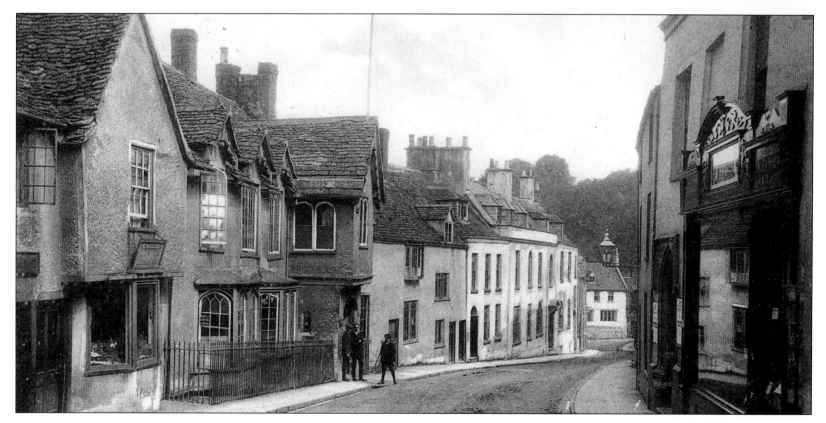

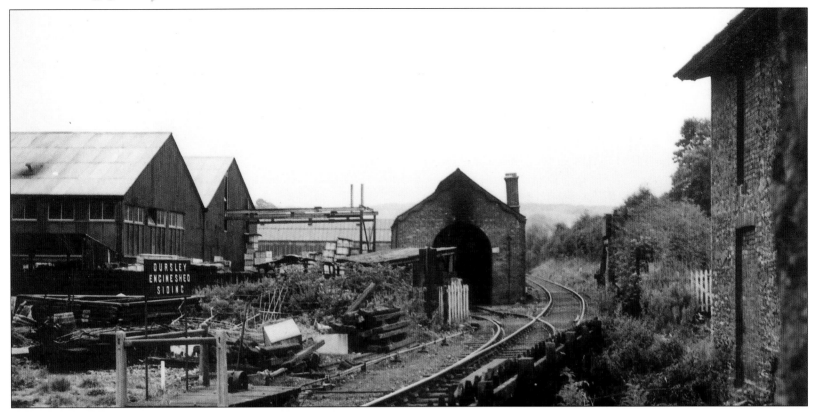

Dursley Donkey was an institution, but it was grimy, old-fashioned and slow. I was one of the hundreds who went on that last trip, waving flags and cheering for the historic last journey. It was a sad day, but many of us wanted to give the rail service a good send off. Being truthful, closure was inevitable as hardly anyone used the service to Coaley Junction. Train after train plied its way between the junction on the main line and Dursley, stopping at Cam station en route. Unfortunately, they were nearly always empty towards the end of the service's life. People preferred the bus service or their own cars to go to Gloucester or Bristol. Walking down Long Street, waiting for the train, and then changing at Coaley Junction, followed by a walk from the Midland Station in Gloucester to the centre of the city – this could not compete with alternatives in the age of convenience.

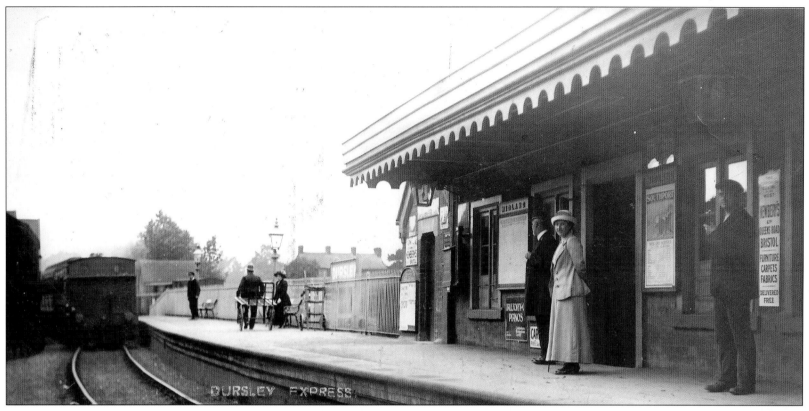

In the 1950s I often had free rides on the footplate if the drivers and firemen were friendly. This was a hot and dangerous place for a small child, and something that would be almost unthinkable just forty years later. My great-uncle Archie and Auntie Ellen (Nell) lived at Everlands. I would fish for newts in their pond, and when the engine whistle hooted, I and whichever playmate was with me would scamper along the road and up on to Gallows Bridge so that we could be in the middle of the smoke as the train went by. The drivers always waved. Come to think of it, the sun always shone also. Halcyon days akin to Nesbit's *The Railway Children* – minus the plot.

The railway was opened to traffic on 25 August 1856. It was closed for goods services on 1 November 1966 and became finally defunct when Lister's closed their private siding on 13 July 1970.

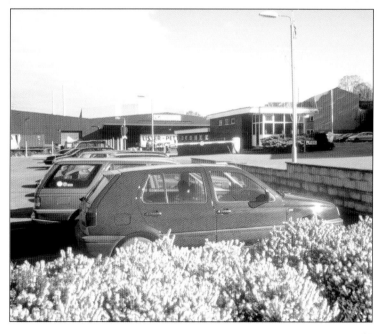

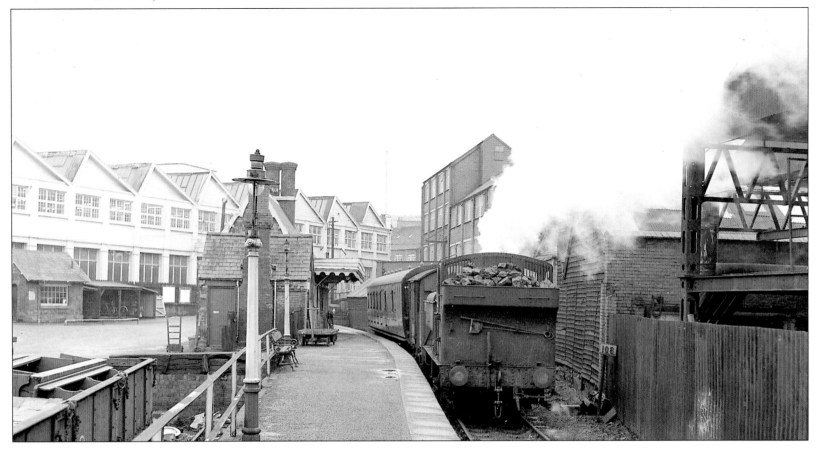

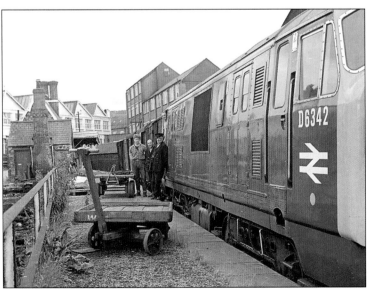

The photograph on page 40 shows the Victorian engine shed during the final days of the service. On page 41 is a view of the station in happier days, when the service was the only sensible method of reaching the outside world. This photograph is probably from the 1920s. The two views on this page are of the last few years. The top photograph shows the Dursley Donkey passenger service in 1962, pulled, as usual, by a tank engine. The bottom photograph shows one of the diesel locomotives used for the goods service at the end of the line's life. Finally, on page 43, the signs of dereliction after the service is withdrawn.

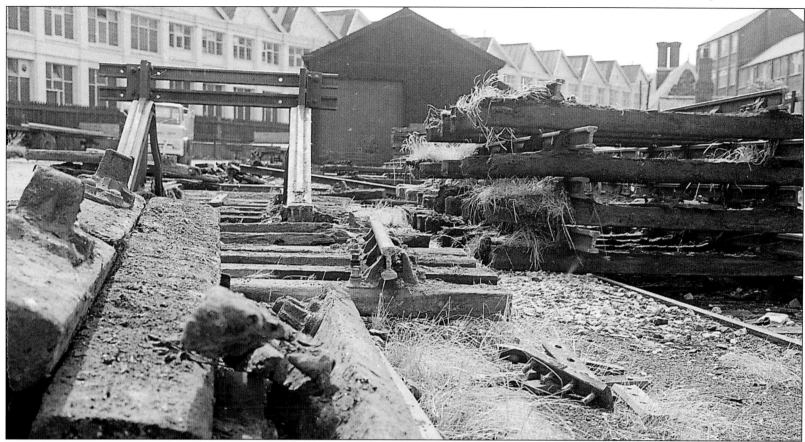

The colour photographs show the area once utilized by the station and lines. It is now part of the Lister-Petter works and car parks.

In the top photograph the ornate chimneys of the station are visible. Behind the station is the Lister Churn Works, the buildings that replaced Edward Gazard's workshops (see page 27). The workshops, demolished in 1903, had been a timber works and the Churn Works remained a timber works – right up to the day in July 1983 when that and all the buildings opposite were destroyed in a huge fire. The Churn Works was so named from the wooden churns that Lister's made in their early days. Eventually the main timber product lines were changed to a popular range of teak furniture.

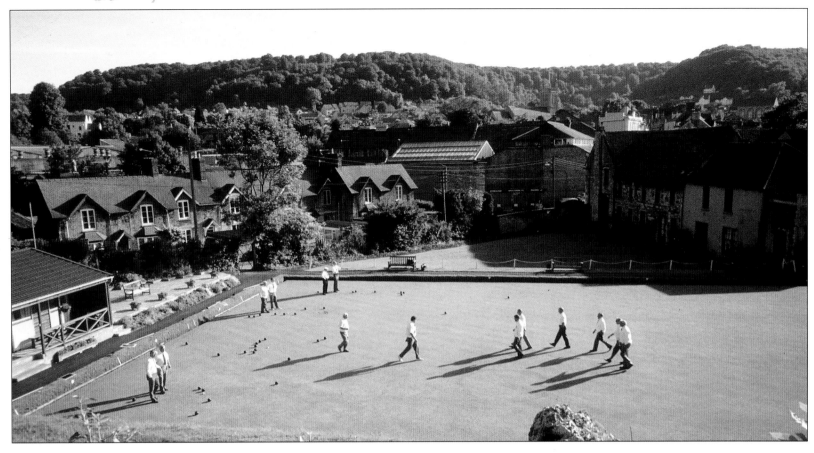

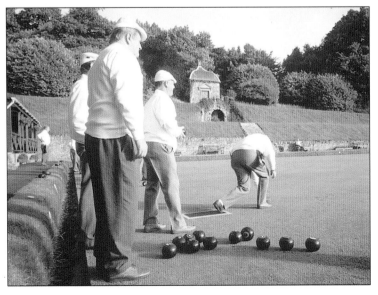

An early evening game of bowls at Lister Bowls Club, housed behind the Priory. The charming small building with ornate roof in the bottom picture is very old and has been in paintings since the 1720s. In so many photographs of Dursley taken from good vantage points around the hillside it has stood out as a distinct feature.

The Priory is a fine house and one of the few jewels in Dursley's architectural portfolio. It was built in 1520 by the Webb family, clothiers of Dursley – and later of Egypt Mill in Nailsworth. The site now covered by the bowling green was previously partly covered by Townsend Mill and the Ewelme is culverted. This area is adjacent to Chestal, so-named from its Roman origins. Was Chestal a villa? If so, it is quite likely that the villa grounds came down to the river.

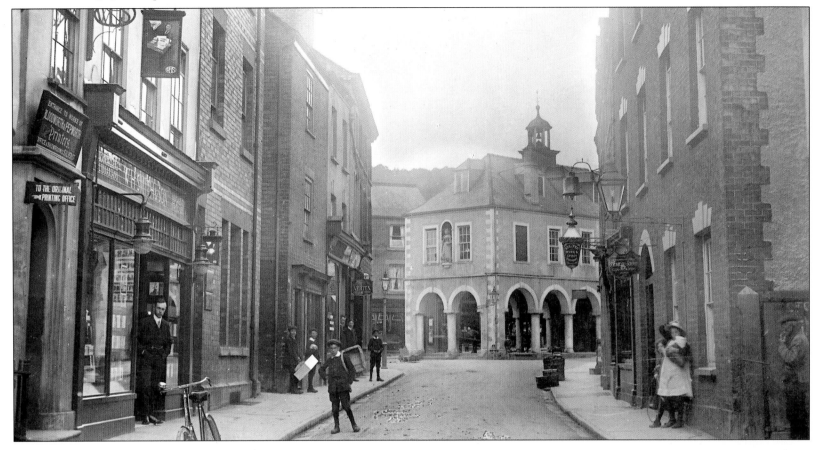

The three views on the previous page show the bottom of Long Street cleared of houses. The green sward was originally built on and the large houses were successively cleared in the 1960s and 1970s. At one time it seemed as if the clearance was going to continue right up to the Reliance Works. Long Street contains a few interesting buildings and the top two photographs demonstrate that not all is lost.

On this page we have come back up Long Street and can see the premises of W.H. Smith as they were around 1910. The shop remained under W.H. Smith's ownership until the 1960s and is now part of the Conservative Club. The façade has been remodelled to remove the shop window and put the building as it would have been in it original state.

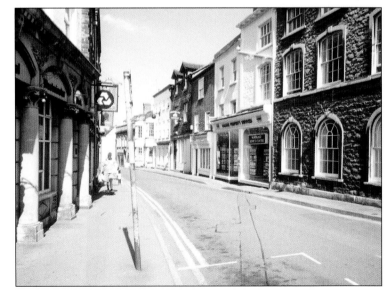

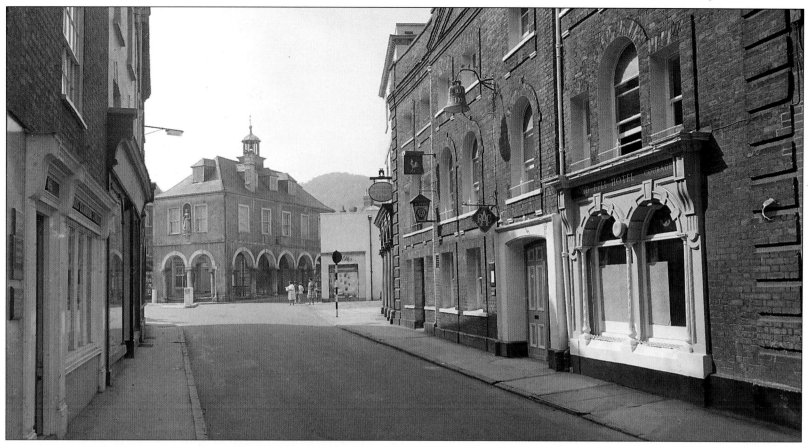

The Old Bell Hotel in 1963. The pub lounge now looks little different from this photograph although its tiredness after almost forty years does show through. In the 1960s the Old Bell was the smartest pub in the town and at that time was a Georges Brewery tied house. Now we hardly have any pubs. In the nineteenth century it was the home of courts and coroners' inquests. It shared, along with the Bell & Castle Hotel in Parsonage Street, the hosting of all the big local functions and each hotel had its own coach and horses to collect travellers from the railway stations.

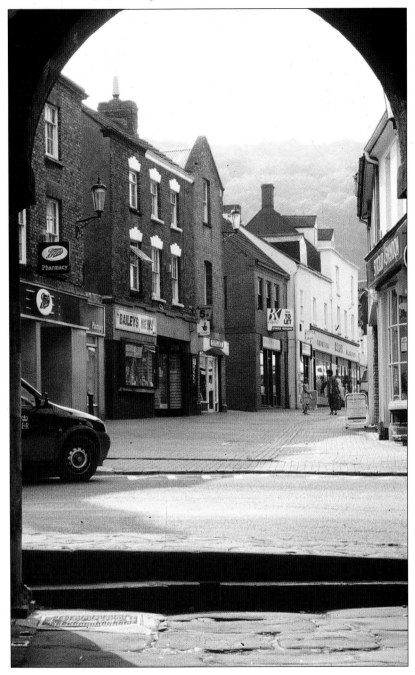

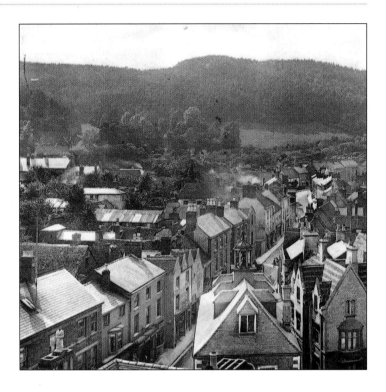

*Above*:

This view from the church tower gives an interesting perspective on Parsonage Street early this century, which hardly changed until 1959 when the police station and magistrates' court were demolished. The scale of this building, standing cheek by jowl with the Market House, can be judged from the photograph. Between the two there was room for pedestrians, but nothing more. The Victorians had it right. Crowd the buildings in. Create varying and busy street scenes where every corner provides the opportunity of a new and interesting vista. Before 1959 you would have had the opportunity of discovering Dursley with little corners and interesting alleys. You would have seen wonderful views of the church, framed by an ornate gateway and a fascinating arch. The churchyard was quiet and private, a place for solace and contemplation. Now the church is bared like a ravaged and distressed maiden, vainly searching for a garment to make herself decent.

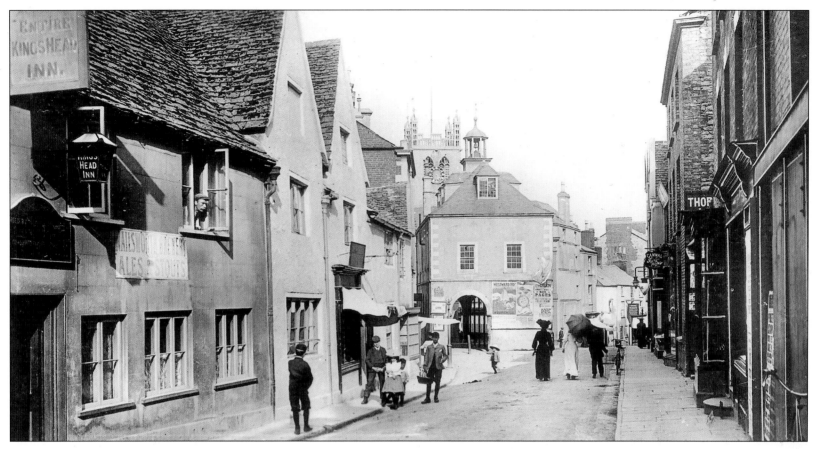

*Above*:

This photograph has been reproduced several times, but as this is a 'best of' selection I had to show it once again. Parsonage Street was the widest street before the vandals descended upon the town. The narrowness of the passing way between the Market House and police station is visible here although the last building shown here is actually the old post office. The police station is just hidden with merely its grand chimney visible above the other roof tops. Every building in this row on the left has now gone, to be replaced by less than exciting architecture. The old buildings may have been draughty, damp and with leaking roofs, but what character!

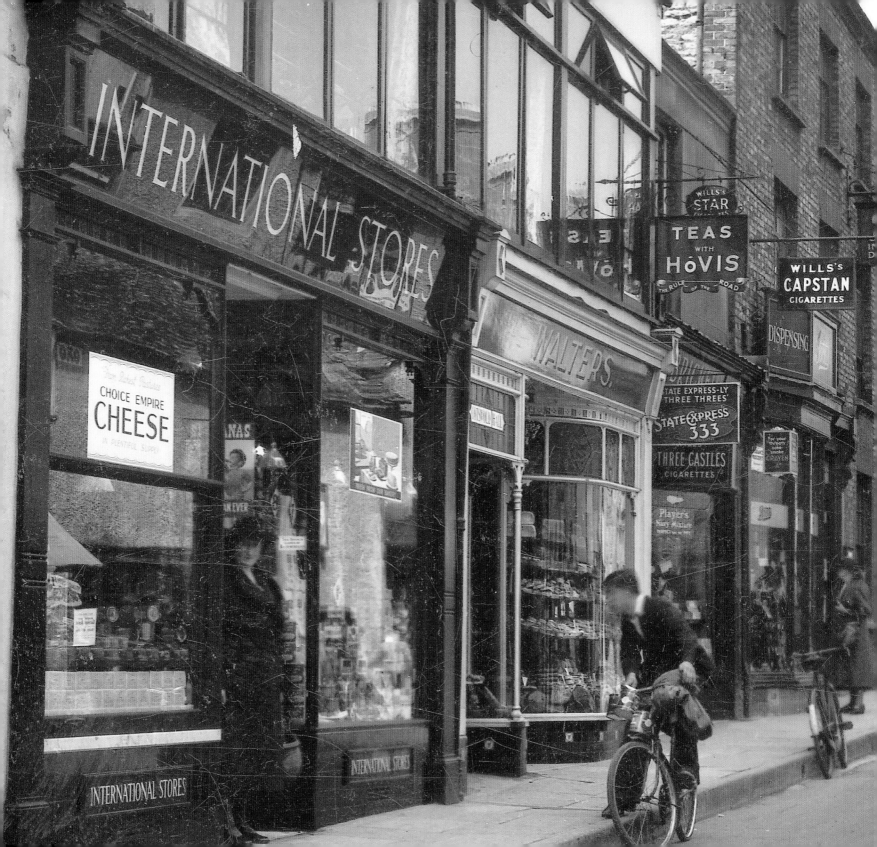

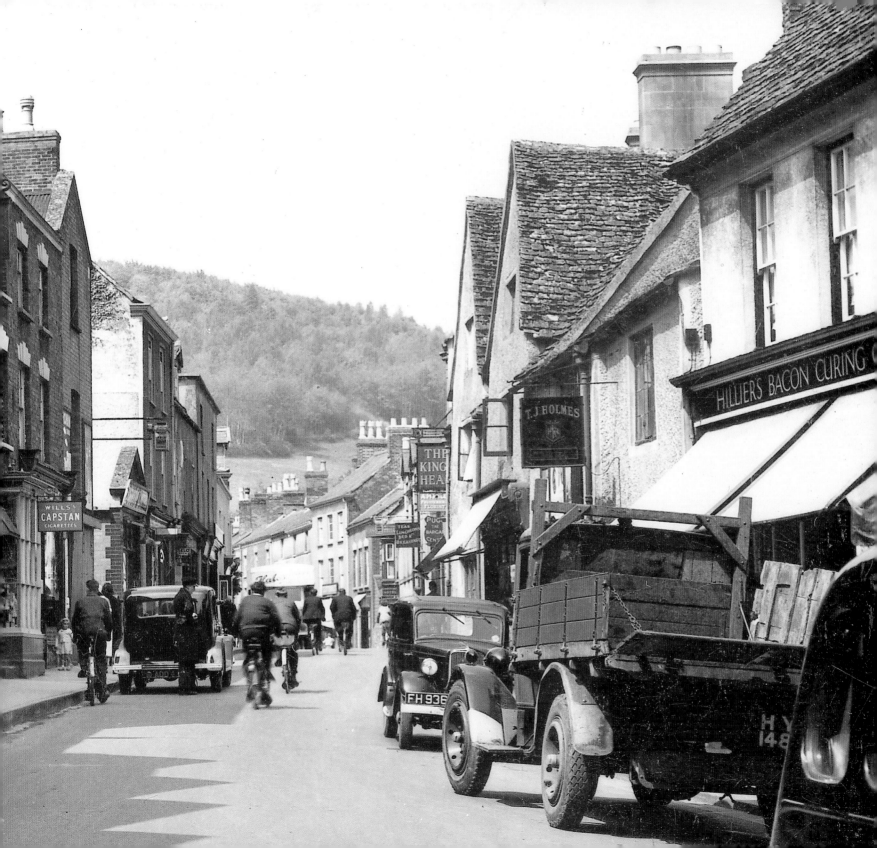

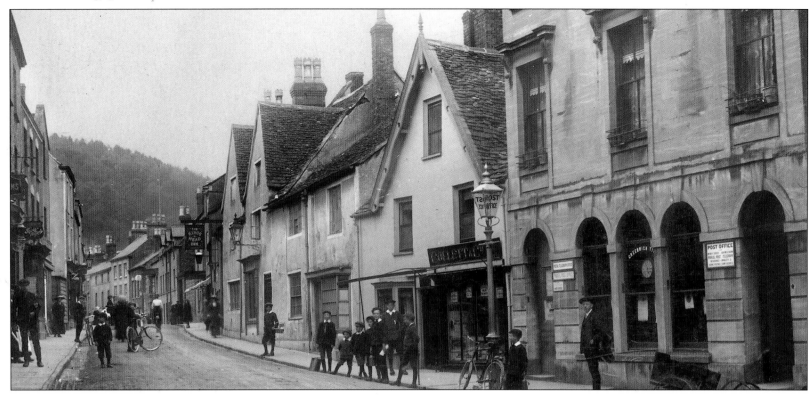

The previous two pages show a splendid post-war view of Parsonage Street. It is midday in late spring. Workers from Lister's cycle home for their dinner. A chauffeur stands behind his car waiting for his employer. Choice Empire Cheese is available from the International Stores and there is not one yellow line in view.

The photograph above is almost fifty years older and shows the frontage of the old post office. A group of young scholars with starched white collars take an interest in the photographer and a delivery boy with basket shirks his duties for a few minutes to see what interest develops. A lady bicycles up the right-hand side of the road in the sure knowledge that no motor car will descend upon her.

The view to the right could almost have been taken from the same point if the photographer had merely turned a little to the right. Now, nearly a century later the character has gone and is exchanged for two vandalized trees and some interesting concrete street furnishings.

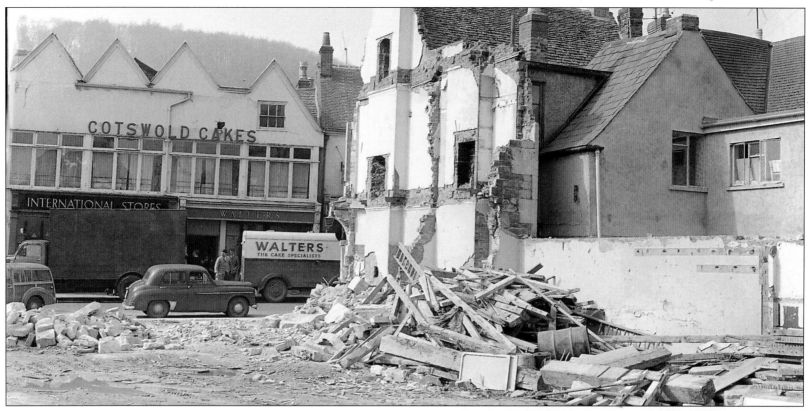

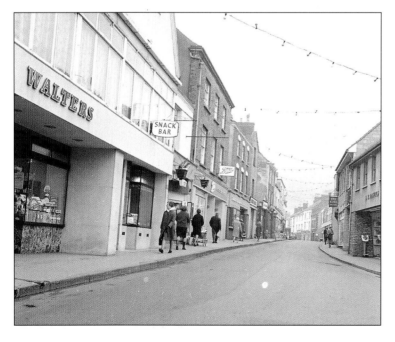

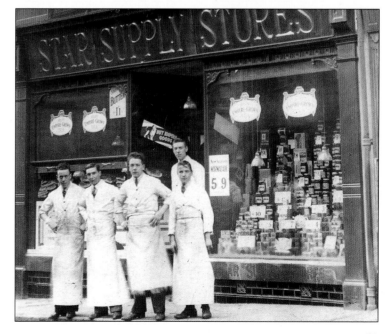

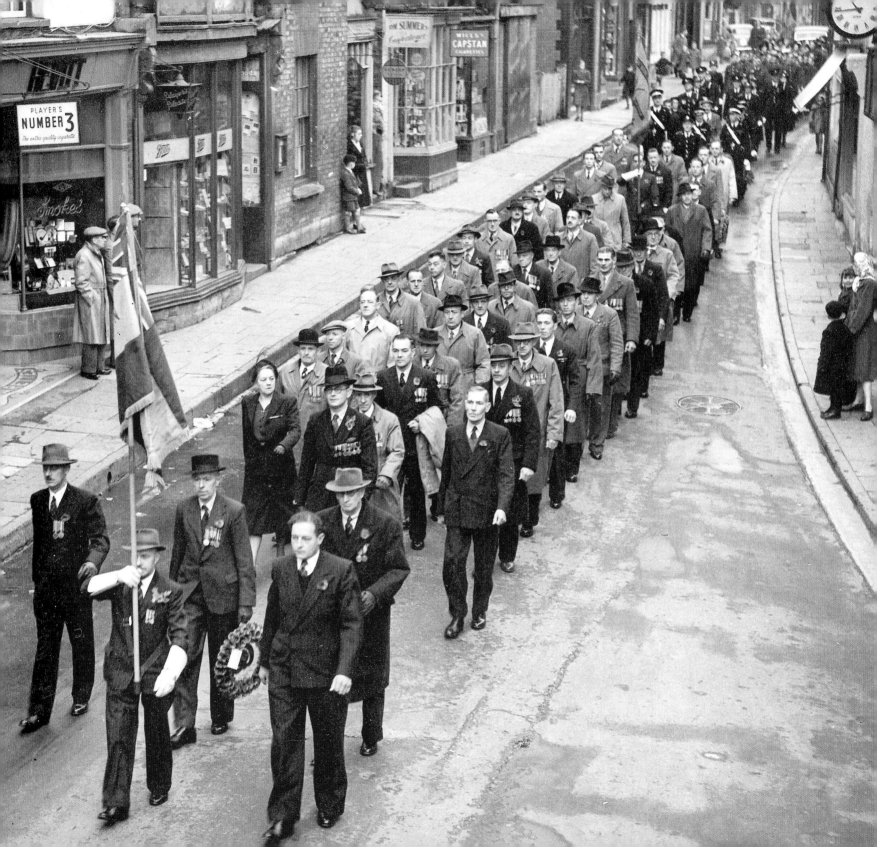

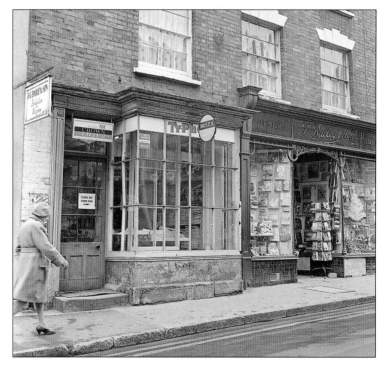

*Page 53*:

The top photograph shows the demolition of the building that was the post office, completing the demolition phase that exposed the Market House. The bottom left picture shows Walters' new frontage in 1968. At bottom right is the Star Supply Stores, later to become the International Stores.

*Previous page*:

Remembrance Day parade in Parsonage Street, *c.*1950. Proudly carrying the standard is my maternal grandfather, Harold Mayo. He was a quiet, shy man but intent on remembering the fallen. It was only with great difficulty I could ever get him to talk about the First World War. He told me about leading packhorses carrying shells, but I believe the pain was too great for him, for he would always change the subject.

*Left*:

F. Bailey & Son shop frontage, 1965.

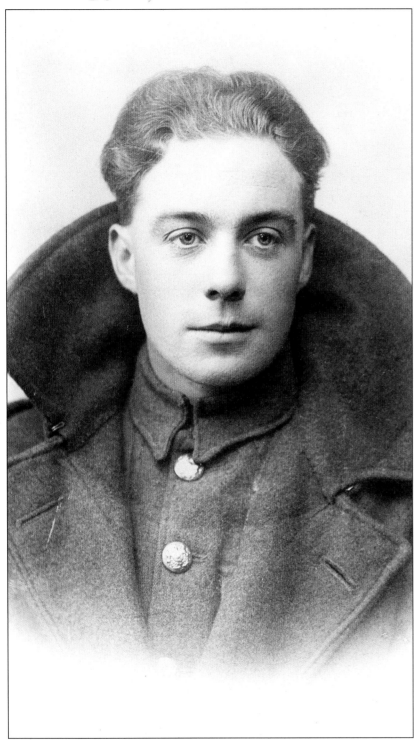

*Above*:

The current view towards the fire station from what was the entrance way to Castle Farm. In the 1950s when at Dursley County School I had the joy of seeing the cattle marched down Parsonage Street twice daily for milking. An almost impossible thought in this age.

My cousin Arthur told me that when he was at the County School, during the First World War, he had the job of collecting a cart horse every morning from the field at Trolleymoors, next to the Gas Works. He rode this bareback and took it to Castle Farm, adjacent to the school.

*Left*:

Harold Mayo at eighteen years of age in his army trenchcoat. A Nailsworth boy by birth, he started work at Daniels in Stroud and later moved to Dursley to work at Lister's. This photograph was taken before he was introduced to the horrors of the Western Front.

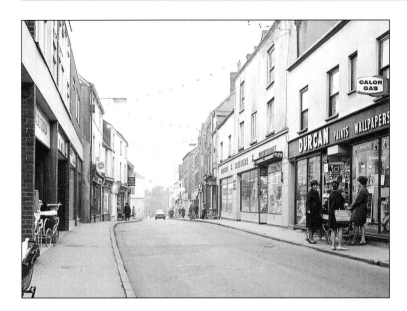

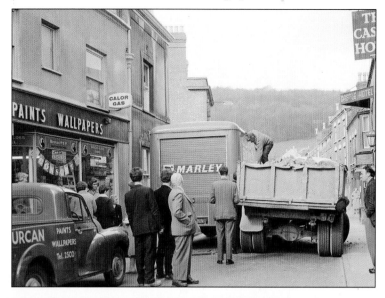

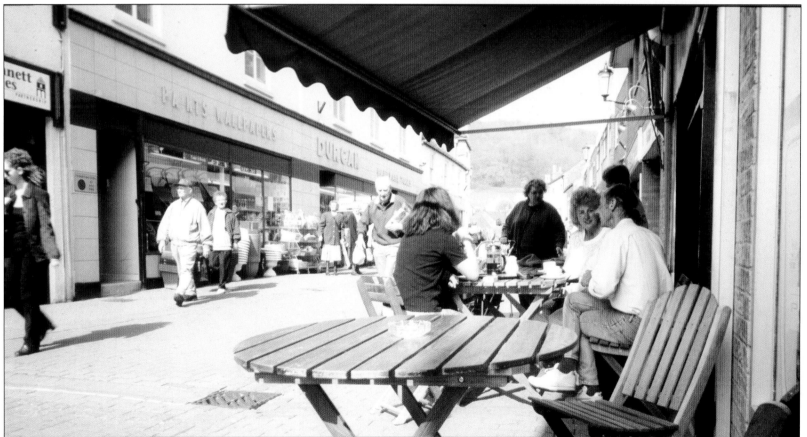

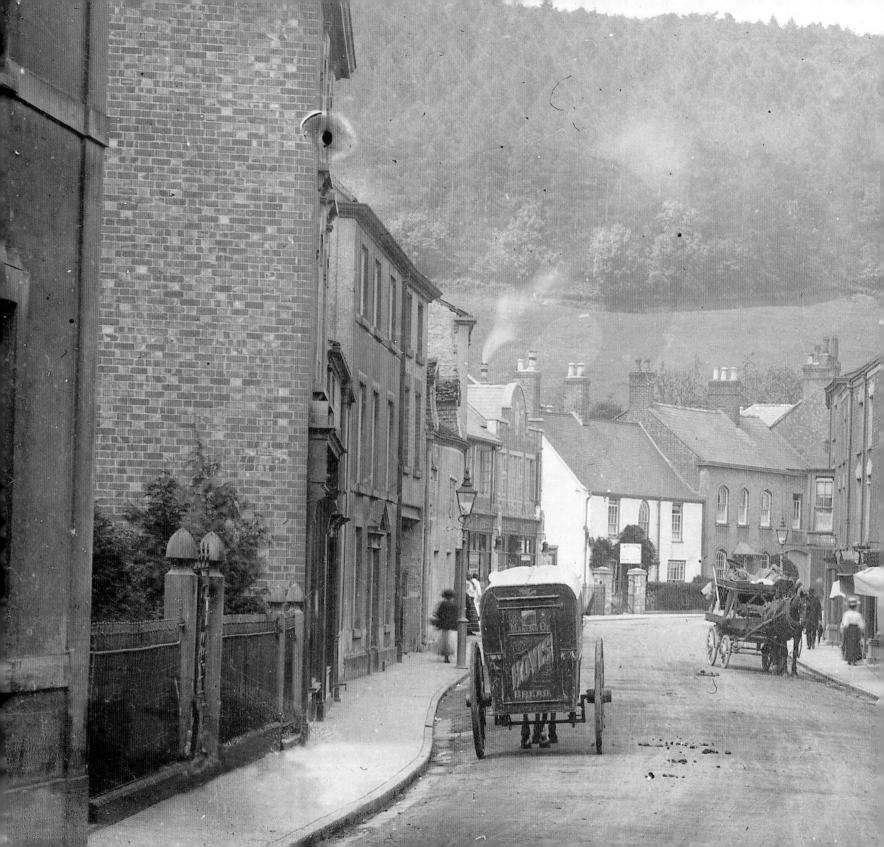

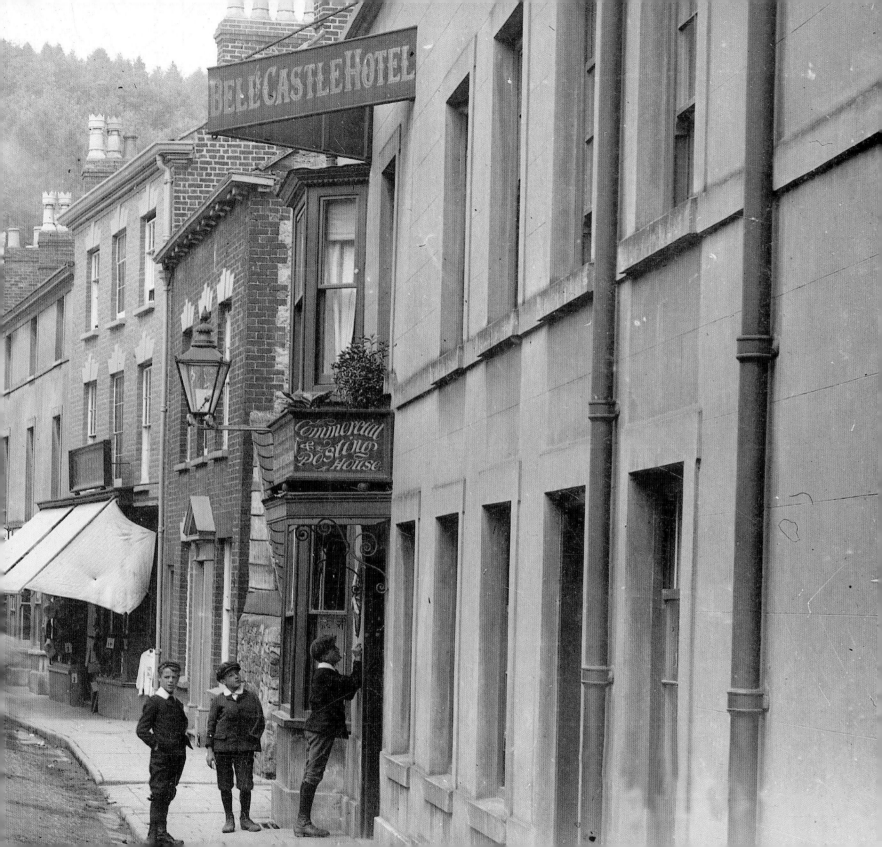

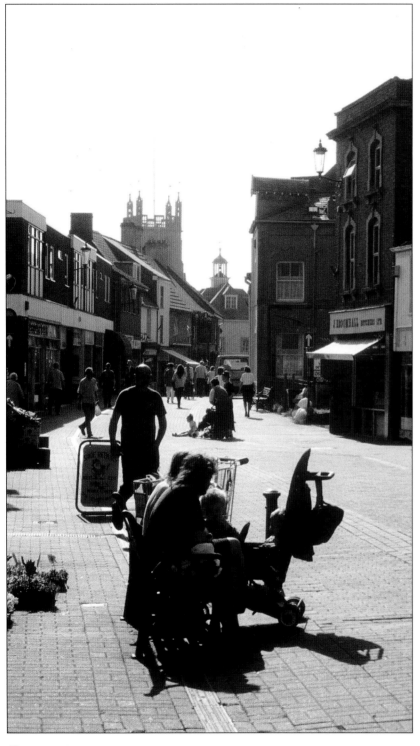

*Page 57, top left and top right*:

A lorry crash outside Durcan's in 1964. The other picture and the colour picture show Durcan's shops thirty years apart. The photograph on the right is from 1968 in the modestly sized shop. The colour picture is the current view in the adjacent premises, the Durcan empire having grown. May the business long continue to thrive, providing that service of being able to find almost anything!

The previous two pages show a splendid view of the top end of Parsonage Street around 1910. The road remains without tarmac at this period, although in good state of repair. The Co-operative Stores has just been built and opened. The Bell and Castle Hotel still proudly announces that it is a commercial and posting house. Behind the middle boy can be seen the Cotswold stone wall flanking the one side of the gate leading to Castle Farm. The Bell & Castle came down in 1965, sadly before I had the opportunity of drinking in it.

The building that replaced the Bell & Castle, as seen in this photograph, is one of the greatest additions to our heritage of 1960s architecture. Its graceful flat roof complements the strong brickwork, rounded off by the quiet band of white that adorns the discreet frontages.

*Below*:

Parsonage Street, December 1968.

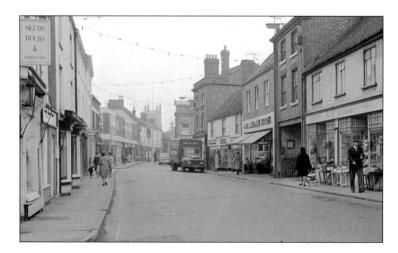

The photograph to the left shows the tired frontage of the Bell and Castle Hotel in March 1965. It is boarded up, as if resignedly awaiting its fate to be replaced by something joyous and new. At this time Castle Street commenced at this point and Parsonage Street remained two way – note the sign for the one-way street and no-entry restrictions. This was only to remain this way for a further month, for in April further gaps were to be blasted in the frontages.

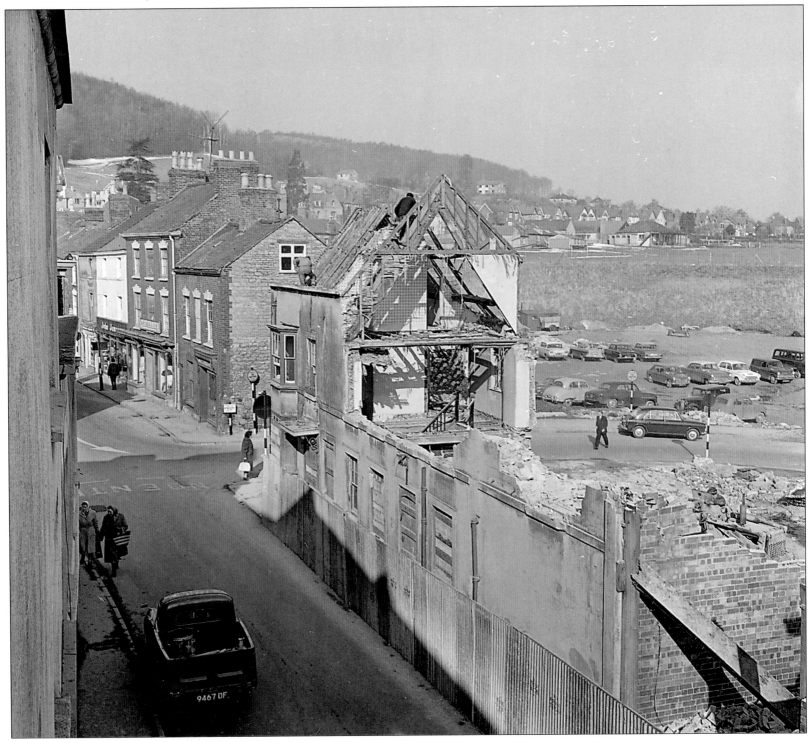

*Previous page*:

Demolition is well under way at the Bell & Castle Hotel. The date is March 1963 and the vandals are preparing to move towards the telephone exchange to commence their assault there. This action was taking place just after the worst winter in sixteen years and snow can still be seen just below the woods. In the distant the building of Westfield is in progress.

*Right*:

This photograph shows the demolition from the Castle Fields side. The profile of the first stage of the Parsonage Street bypass can clearly be seen. At this date it was one-way with up traffic still using the street. In the background can be seen the old Burton's grocery shop, later to be taken on by Durcan's.

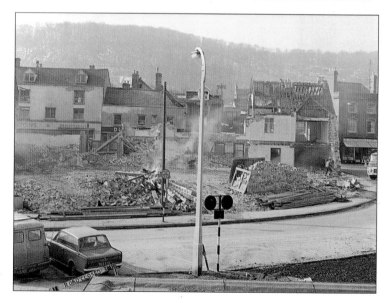

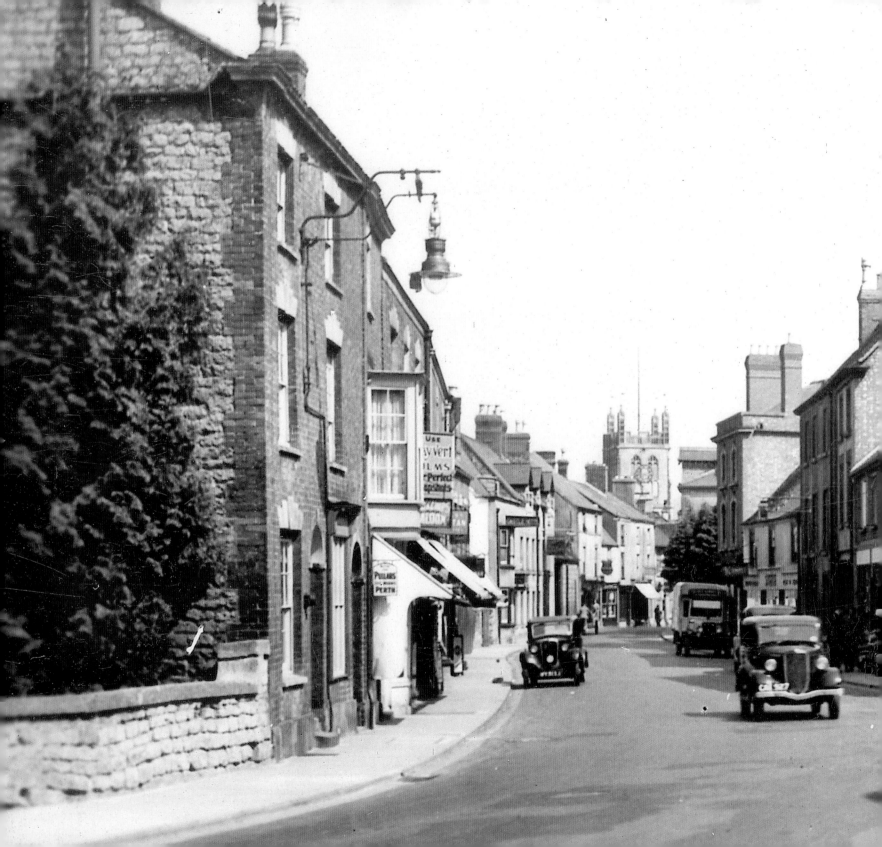

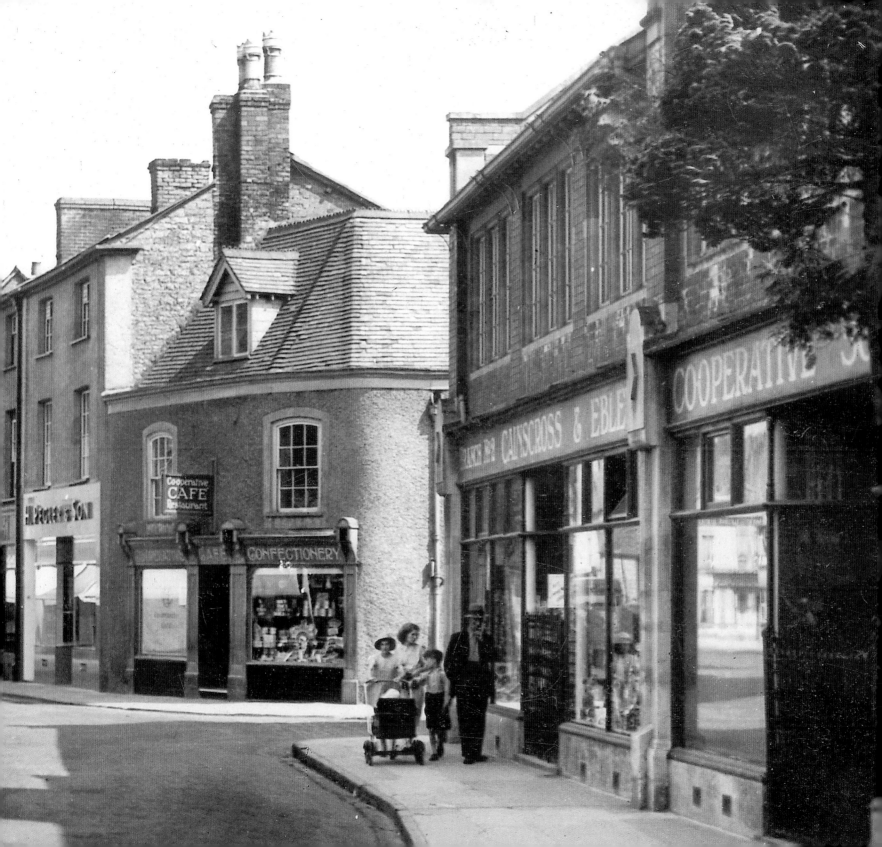

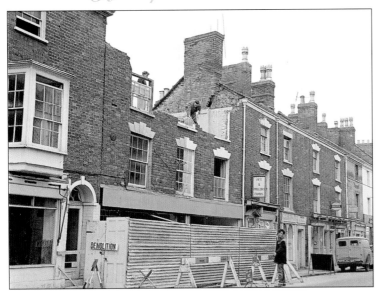

*Previous pages*:

This view of the top of Parsonage Street is probably just post-war, 1946 or 1947. The buildings on the immediate left were demolished in April 1963 to make the full length of Castle Street a possibility. Before that time the post office was effectively set back from the road by the lay-by framed by this low Cotswold stone wall. On the right, the entrance to May Lane is narrow literally little more than a lane – much less than its current width. This was not to remain the case for very long; see page 69. The picture on the left shows the April demolition in progress. The photograph below is of Mrs Higgs outside her shop around 1910. This building is a surprising survival.

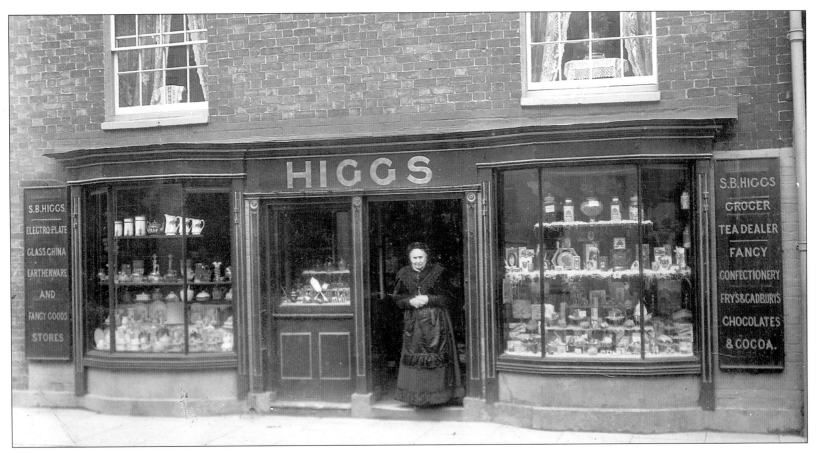

*Below*

Parsonage Street in 1968. Selby Robinson's shops are clearly visible on the right. The International Stores has now moved up the street, but is occupying modestly sized premises. The entrance to Bloodworth's building yard may be seen between the two. Later transmogrification of this site has resulted in the current Somerfield premises.

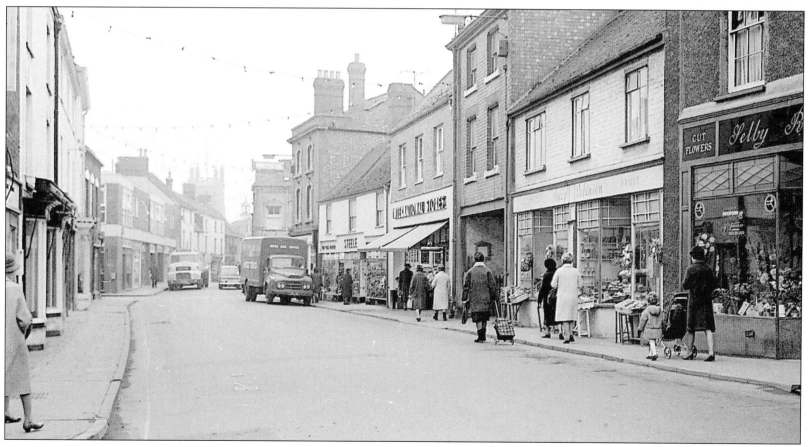

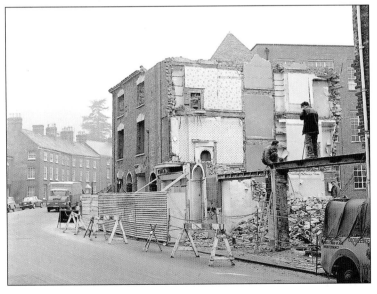

The opening up of Castle Farm provided the benefits of additional parking spaces and space for the swimming pool. The unfortunate side effect is the street frontage of Castle Street – a motley collection of backsides, some fat, some thin but none of them attractive.

*Left:*
April 1963. The vandals continue in their allotted task.

*Far left:*
Colyton House in January 1962.

*Right*:

The widening of May Lane, February 1962. The Co-operative bakery and a row of cottages goes the way of all stone. At the far end of May Lane on the right-hand side can be seen the first of two houses that remained standing until recent years.

*Below*:

Pedestrianized Parsonage Street with an attractive concrete barrel and a few pansies. The barrel has the distinctive shape of being made in a 1960s cast. The brave new world lives on.

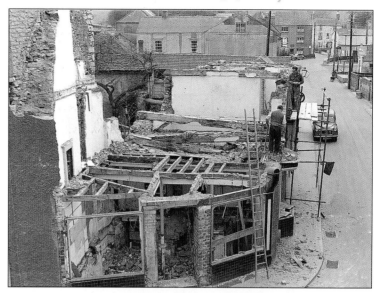

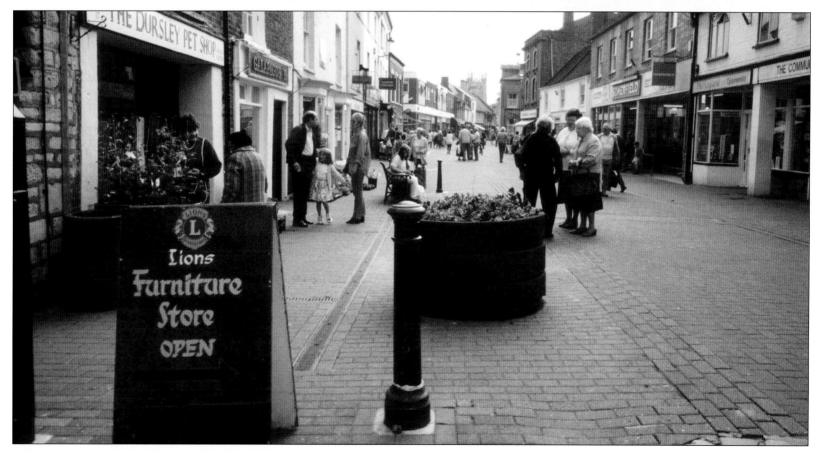

*Above*:

Pig-Face Row, the cottages standing on the site now occupied by the Hill Road car park. I have never discovered how they inherited this name, but some people say they were effectively built back-to-front. As keeping pig at the back of a cottage was not unusual, perhaps this may be the derivation? To the right of the row can be seen the two houses referred to on page 69. Also, note the farm buildings on the site now covered by the bus station. This photograph dates from the 1920s and Garden Suburb is in view, having been built some ten years earlier.

*Far Right*:

A game of pétanque at the Old Spot.

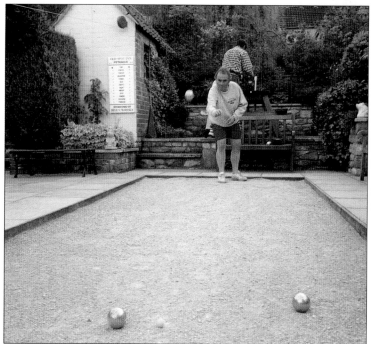

Pig-Face Row is seen again in this 1947 view from the bottom of Broadway. At the farthest visible part of the Slade can be seen two cottages that were only to survive this photograph by a few years. Note also the builders yard behind what is now Somerfields, the two cottages to the left of the Timber Turneries and the high roofs of the police station and courts.

*Right:*

This view of Hill Road shows the Old Spot in the distance. Dursley is in need of more good pubs and real restaurants. At the beginning of the nineteenth century the Old Spot was a school. At that time the pubs in the town were: The Bell & Castle, (as photographed in this book, in Parsonage Street); The Kings Head, (still in existence, although rebuilt in the 1930s); The White Lion, (Parsonage Street, now the Cheltenham & Gloucester); The Boot Inn,

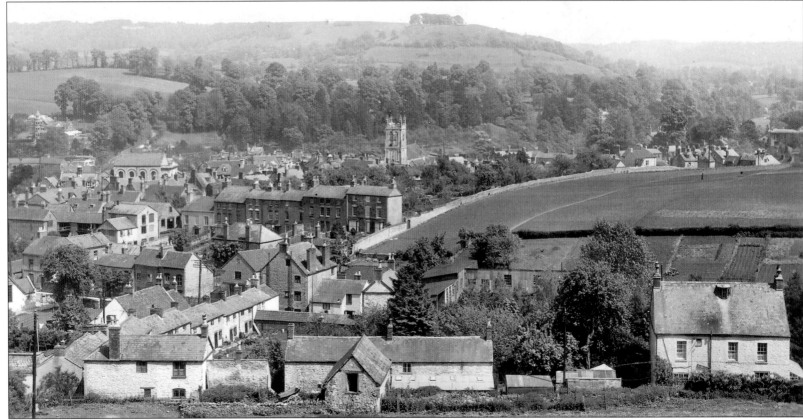

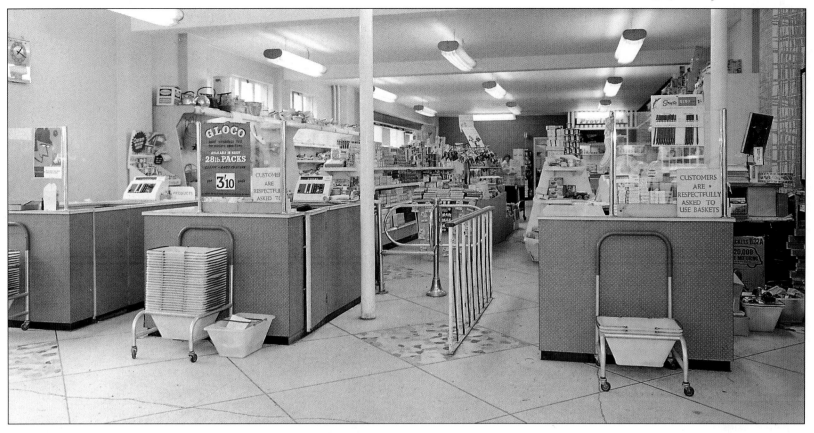

(Wilkes'/McIlroy's site); The Lamb Inn, (opposite the Boot); The Golden Hart, (the Conservative Club); The Old Bell, (still in existence); The New Bell, (now R.P. Jones); The White Hart, (Long Street, opposite the entrance to the Reliance Works); The Hen and Chickens, (upper Woodmancote); The Crown, (Woodmancote); The Bell & Apple Tree, (Water Street); Blackboys (Kingshill) and, last but not least, The Railway Inn (bottom of Long Street, although this did not come into being until the 1850s). The Bull in Woodmancote and The Crown in Long Street presumably came later in the nineteenth century.

*Above:*

The Co-operative Stores is remodelled in 1963 and customers are respectfully asked to use baskets. This was such an innovation at the time but looks incredibly dated in our days of bar-coding and supermarkets.

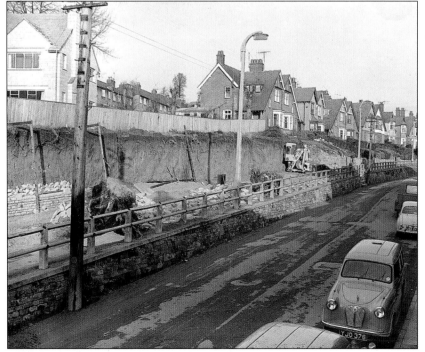

*Above:*

A panoramic view taken from the field below Westfield Wood. Immediately in front is Garden Suburb. This estate of fifty-eight houses was built for R.A. Lister & Co. Ltd. The plan was to sell the houses at £200 each, on easy terms of four per cent interest. The announcement was made in 1908 and the houses were completed in 1911. The facing hills are, from left to right, Frocester Hill, Cam Long Down, Cam Peak, Uley Bury and Smallpox Hill. From the right of this view, the continuous woodlands in this photograph provide a sheltering curtain around the valley as it winds it way up to, and almost surrounding, Uley. They are Coopers Wood, Bowcote Knoll Wood, Rook Wood, Virgin's Corner Wood, Whitley Wood and Owlpen Wood.

*Left:*

The building of the Golden Wall in 1962. The building work substantially widened this section of Kingshill Road.

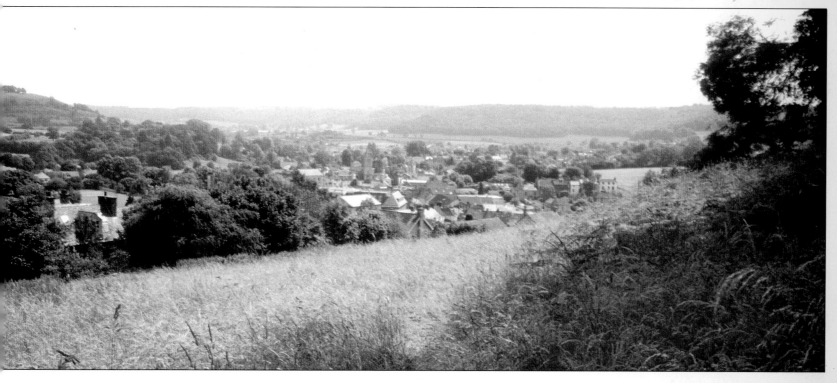

*Below*:

Garden Suburb in 1911.

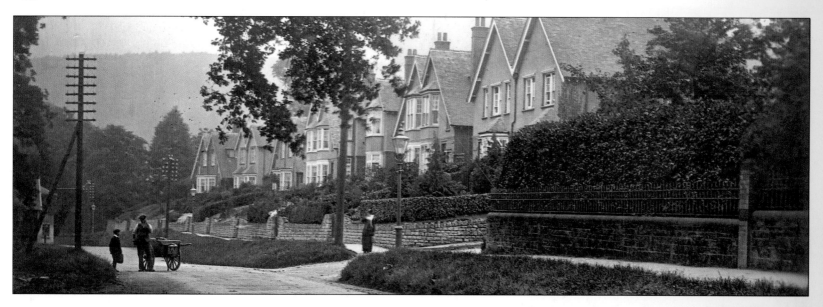

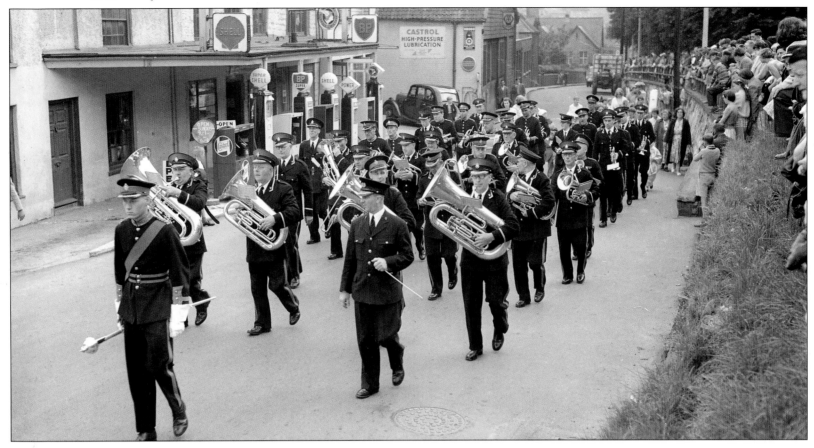

One of the highlights of the year was the Gala Day, usually held about the second Saturday in July. This was a major event for the town and it combined with a fun fair and a circus on the Recreation Ground. It was a one-day event and almost everything took place on the Rec. It was an exciting time for schoolchildren. Earlier in the week the circus would arrive, followed by the fun fair. The circus elephants arrived by train at Dursley station and would be walked up Long Street, Parsonage Street and Kingshill Road towards the Recreation Ground, the trunk of each elephant holding on to the tail of the preceding animal.

Attwooll's would arrive and erect huge marquees for the produce shows and other events. One of the most popular attractions was the procession of floats with many local organizations working to produce amusing and ingenious tableaux on the backs of lorries or trailers. One of my early memories is going with my father on the Saturday morning to Kingshill House, where he and other Rural District Council staff would put the final touches to their float. The procession commenced in Woodmancote where all the lorries would rendezvous. The police would close the roads at Kingshill, Woodmancote and Uley Road. The procession would then commence its slow journey behind a marching band. Down Bull Pitch, up Silver Street and Parsonage Street, along Kingshill Road and down Rednock Drive, along the Knapp and then into the Recreation Ground by the bottom gates.

The photograph on this page shows the band of the 1959 procession outside Dursley Garage. Note the buildings behind the pumps, demolished just a few months after this photograph was taken. Note also that Kingshill Road is narrow at this time. The road was widened three years later and the new 'Golden Wall' built.

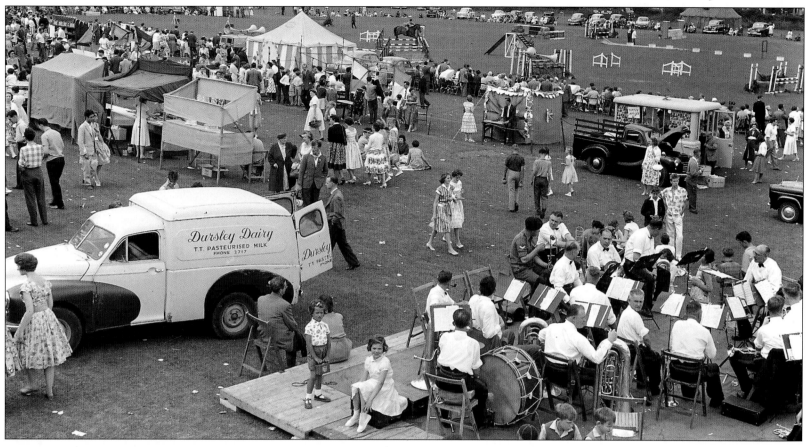

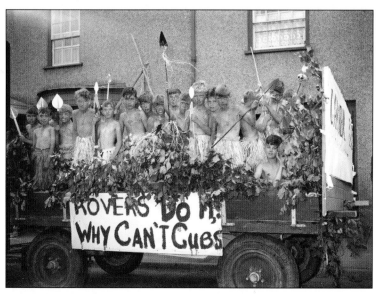

The picture above is also from 1959, showing some horse jumping activities later in the afternoon. On the left is the 3rd Dursley Cub Scouts' float from 1960. I am on the float but will not say where! Others I can see and remember are Peter Benjamin, David Jackson and Stephen Cook. I should remember most of the others but cannot. I was only ten at the time and much has filtered through the brain since then. We were all dressed in raffia skirts (very embarrassing) and painted with cocoa powder mixed in water.

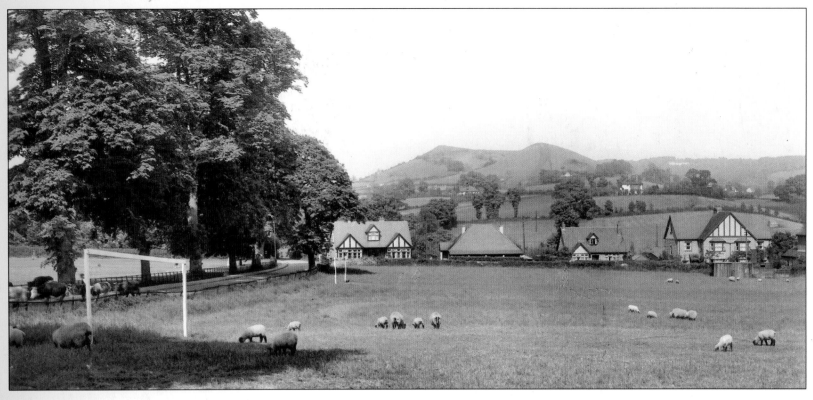

*Above:*

The Recreation Ground in the 1930s. The two fields that made up the 'Rec' were put up for sale in 1912 for the sum of £2,750. Sir Ashton Lister, feeling that the growing town needed recreational space, offered £500 towards the purchase. The Dursley Town Recreation Ground Company Ltd was formed to purchase the land and trade as 'recreation and pleasure ground and club house proprietors.'

On the left of the photograph, cows can be seen walking up Rednock Drive. These would probably have been walked down to Castle Farm for milking.

*Bottom right:*

The new biology block is opened at the Grammar School. The year is 1964 and I seem to have got into the picture. The Rednock Estate had been owned by Captain Graham, an ex-India man, having served in the East India Company army. It was originally called 'Oaklands' and renamed

Rednock after Graham's Scottish connections. I have been unable to discover whereabouts in Scotland the prototype Rednock was but would like to have the riddle answered one day. Captain Graham died in 1909 and the estate was split up. The house and the grounds were purchased by Gloucestershire County Council in 1921 and Dursley County Secondary School came into being. In 1947 the name was changed to Dursley Grammar School.

Nothing of the original house now remains, but memories live on of the decrepit rambling house where they attempted to educate me. I have memories of 'Joe' West swirling down the corridor into the yard causing straggling lines of noisy boys to miraculously speedy straightness and immediate silence. Wherever he went he hurtled, with gown billowing out behind him like a batman cape. Wherever he went chaos turned to order and noise to silence. If 'presence' is a trait given to us at birth he had the share of several people put together.

*Below:*

A detail from the 1962 school photograph showing 'Joe' West with his ever steady gaze.

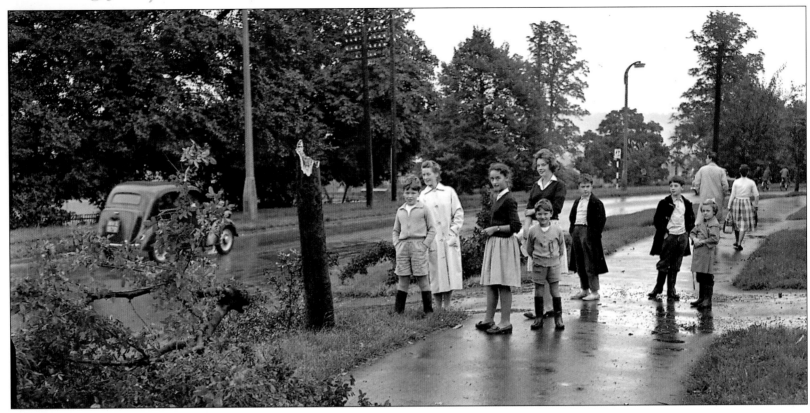

*Above:*

Kingshill Road in 1960. I forget the exact date, but it was a summer Saturday and early afternoon when this picture was taken. We were having lunch and I was sitting looking towards the window. I thought I saw smoke and said 'Lister's is on fire'. My father looked at it and said 'That's not fire, it's a whirlwind'. He had us running around the house shutting the windows. The whirlwind came between our house, 20 Jubilee Road and number 22, taking the roof off the garage of 22, but doing no damage to us at all. It then rampaged up Olive Grove felling chimneys and ripping up tiles before its power dissipated in the woods.

Two ancient elm trees were brought down across Kingshill Road completely blocking the road. My father and other local men were quickly on the scene, saws in hand and managed after a good while to clear a way past. I have two photographs of the scene, but unfortunately the more dramatic view of the fallen elms is badly damaged. This photograph shows the Broomfield and Pugh families surveying the damage some time after the storm. That evening, Dursley's 'tornado' made the BBC television news.

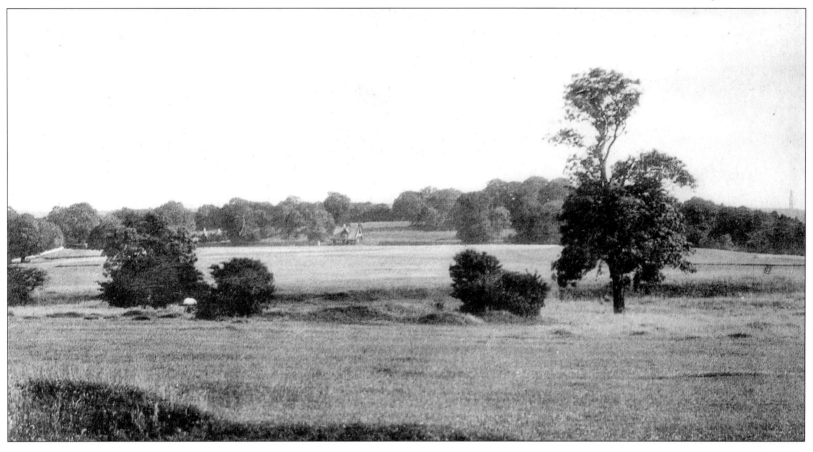

From Kingshill Road we have made a turning up the lane into the woods and up to the hill top. This photograph is taken from an early collotype postcard. The view is looking south-east and the road leading to Broadway is just out of sight on the left-hand side. Stinchcombe Hill is a Cotswold peninsula, but one that is slightly different, for all around it it is skirted by natural beech woods, relatively unaltered by man. These beech-woods are a feature of the western escarpment from Birdlip down to Dursley, but some of the finest are in our valleys. The limestone here is the inferior oolite. This was laid down in the Middle Jurassic period and now, 180 million years later, produces an environment conducive to the beech, resulting in strong growth and a dense canopy. In summer the canopy can be so complete as to reduce the light at ground level to five per cent of its full daylight strength – sometimes falling as low as one per cent.

In all honesty I should have rejected this photograph for the quality does not match the standard of most images in this book. I have retained it simply because it shows such startling differences today, one hundred years later.

The extent of Kingshill Park is apparent and both lodges are just about visible. Kingshill Road is a single lane dirt road with a green sward running down the middle. The gasworks at Trolleymoors is hidden from view, but apart from cottages in Upper Cam, everything else is simply farmland. No Lister's, no Kingshill houses, no shops or pubs.

The development in this last one hundred years far exceeds any other development since the earliest days of mankind. The difference between 1899 and 1799 would be nowhere near as dramatic: in fact the main differences might simply have been down to better-developed road networks. Up to the 1790s the main road from Cam to Uley bypassed Dursley. It went up Spring Hill, skirted closely

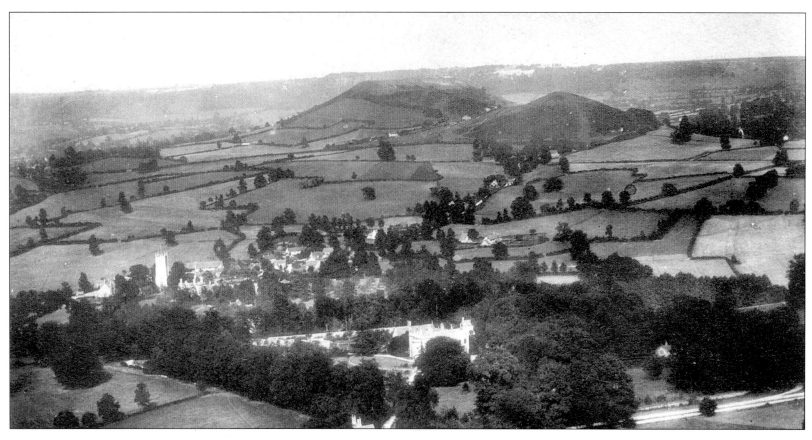

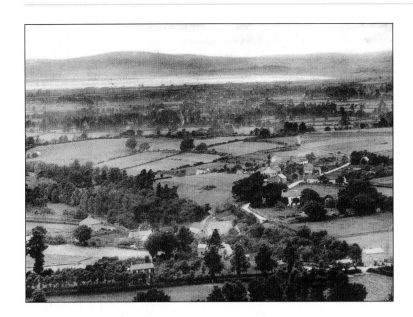

around the base of Cam Peak and then followed Fingre Lane, now merely a bridle path, towards Hydegate. Here, the old road is the same as the current lane and this then reached Uley village via Whitecourt. Skirting around Dursley did not avoid all tolls! Hydegate is called 'gate' simply because it was a toll house and would have had a gate or a bar across the road.

*Left:*

A view of the Quarry taken from Stinchcombe Hill *c*.1900. The row of elm trees is quite young at this time. By the 1970s these trees were mature and provided a splendid avenue leading towards Stinchcombe. Dutch Elm Disease was a terrible scourge to the Severn Vale and this Stinchcombe avenue was a victim. The Yew Tree Inn is to the far right and in the distance may be seen the horseshoe bend in the Severn with the Forest of Dean as the backdrop.

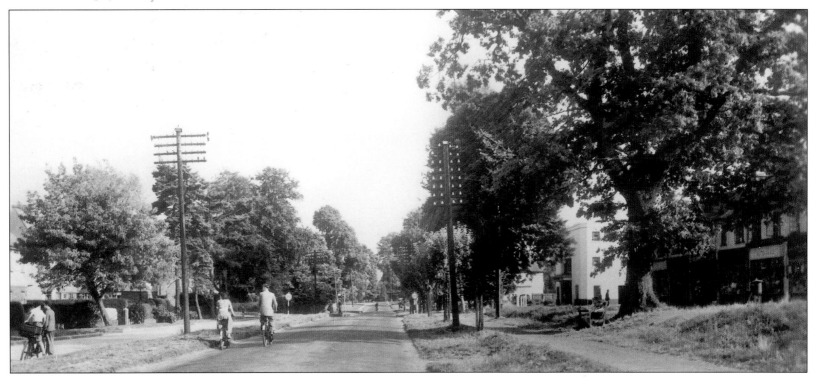

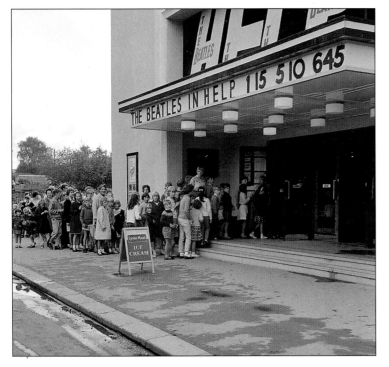

From Stinchcombe Hill our journey moves back to Kingshill Road as we resume our way towards Upper Cam.

*Top:*

Kingshill Road in 1947. Rosebery Terrace and Garden Suburb may be earlier, but Kingshill and Highfields were the first modern 'suburbs' of Dursley, developed from farmland in the 1930s. Jubilee Road was named after King George V's Silver Jubilee in 1935 – which precisely dates the development. This was followed shortly afterwards by the Regal cinema and the Kingshill Inn – all in typical 1930s architecture. Development continued with Kingshill Park and the council housing surrounding the Park. Up to the time when Arthur Sutton left Dursley in 1925, the land opposite Rednock House and Kingshill House was open farmland. Arthur related to me that during the First World War, the fields facing Rednock House were turned into a mini-Western Front. Here the men from the 5th Glosters would be trained in trench warfare before going out to France. As a ten-year old in 1916, with his father in the trenches in France, these practice fields made a great impression on him.

*Previous page, bottom left:*

The Regal in 1965. The cinema industry in the 1950s and 1960s was in severe decline due to the competition from television – then in its ascendancy. The Beatles' films 'helped', but cinemas such as the Regal were never to recover, for when the revival came the cinema's equipment was outdated and its interior furnishings in a state of dilapidation. It was turned into a supermarket and later pulled down and replaced by a purpose-built supermarket. I have wonderful memories, for every Saturday morning, with my 9d pocket money, I would go with my friends to the ABC Minors. This was between 9 a.m. and midday, with an entrance charge of 6d – a tanner to get in and a threepenny bit for the interval ice lolly. There would be a mixed but predictable programme. To begin there would be *Zorro*, or *Batman* or something similar followed by cartoons and then the finale being a black and white cowboy 'B' film.

*Right and below:*

Kingshill Parade as it is now and a similar view in 1953 with a sign advertising Barbara Stanwick featuring in *Jeopardy* at the Regal.

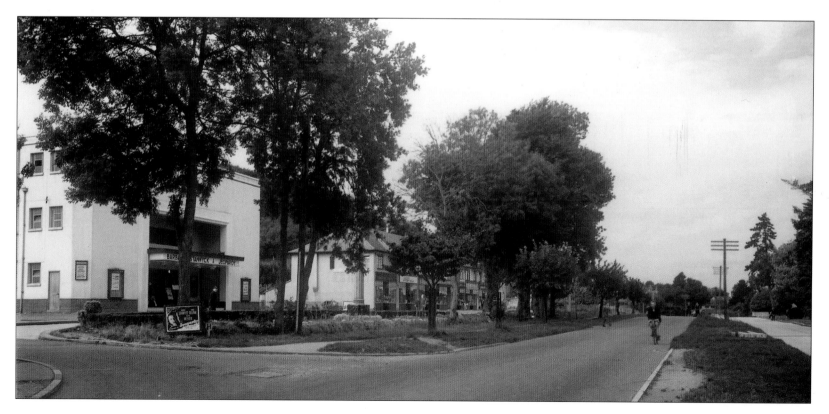

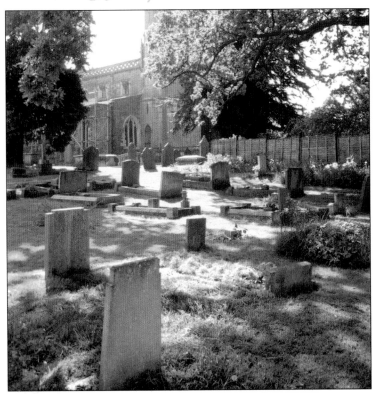

From Kingshill Road the journey takes us down Kingshill Lane, better known as Gas Works Pitch. I recall a wintry Saturday, walking down to the gas works with my father and the rickety remains of what must have been my pram. On to this set of wheels was placed the purchase of two sacks of coke, which were then hauled back up to Jubilee Road. From the gas works we go past Littlecombe towards St George's church, a splendid parish church built in the 1340s by Thomas, Lord Berkeley. This, together with the church in Wotton-under-Edge, was built as an act of contrition following the murder of Edward II in Berkeley Castle in 1327. On the corner of the tower a corbel shows the head of Edward III, then the reigning king, the son of Edward II.

*Below:*

The Crossways, *c.*1925.

*Above:*

Teetotal Cottages, at Noggins Hole, Upper Cam, at some point early this century. Almost everything has changed since this picture was taken. The exceptions are the course of the road and the distant view of the church tower. The cottages have gone, the stately elms have gone.

*Right:*

Cam Hopton School. The school was founded by Frances Hopton in 1730 for the education of ten poor boys and ten poor girls. The splendid three-storey school house was built in the early 1740s.

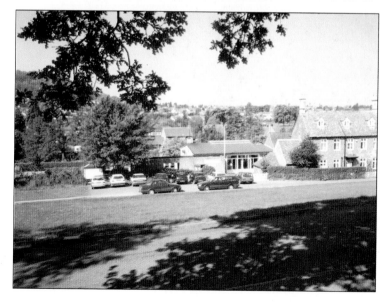

*Below:*

Station Road in Lower Cam, *c*.1905. Note the level crossing and the railway truck next to the Railway Inn. Cam Station is out of sight, but was immediately to the right of the level crossing gate. The railway line was an act of confidence by Dursley businessmen. The first meeting of the proprietors of the Dursley & Midland Junction Railway was held in Dursley Market House on 13 July 1855 with 68 out of the 72 shareholders being present, almost all of them local people. Construction began later that year at an estimated cost of £14,100. Passenger trains began running on 18 September 1856, but the Company found the running costs more than they could cope with and was forced to sell out to the Midland Railway in 1861, with shareholders losing most of their money.

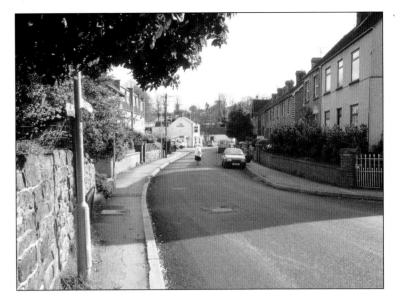

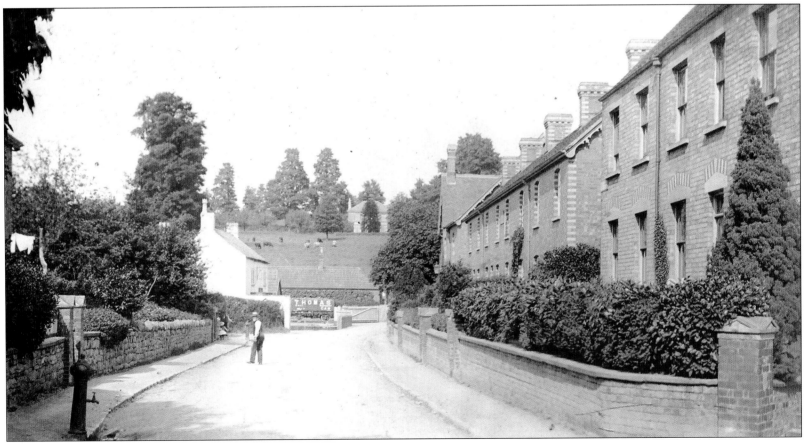

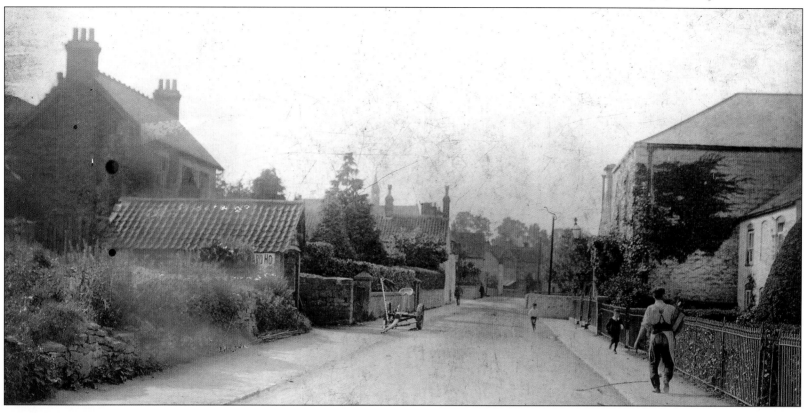

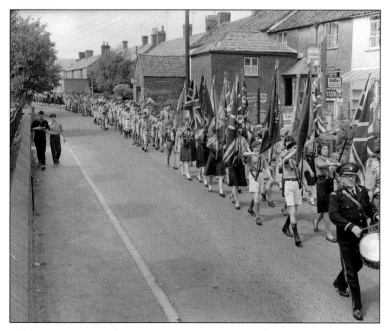

*Above:*

Chapel Street, *c.*1910. This pleasing view has a village atmosphere, a sense that is disappearing, or more realistically, has disappeared from the Cam we now have at the end of the twentieth century. As society changes from the focal centres of the market towns and local sufficiency we lose much of our community spirit. Earlier this century, newcomers to Cam or Dursley would arrive to work at a local factory and through that work would begin to integrate. Now with modern transport and acres of modern houses, people come to live here and work in Gloucester or Bristol. No longer is it possible to achieve the necessary level of integration to keep the community ideal alive.

*Left:*

A parade in Chapel Street in 1966. The ancient centre of Cam was near St George's church in Upper Cam and the development of Lower Cam dates from more recent times,

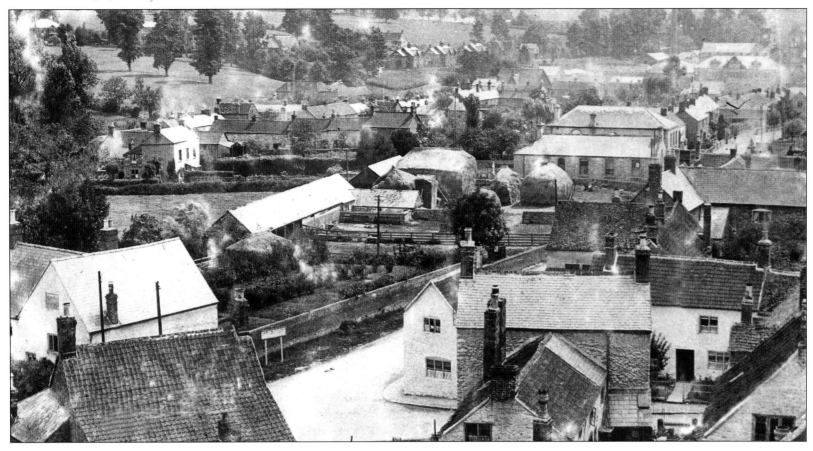

following the course of the road leading towards Gloucester. The cottages in Chapel Street are mainly early nineteenth century and reflect the boom in the woollen industry during the Napoleonic wars. Following the near collapse of the industry in the 1830s the building stopped and only built genuine momentum in the second half of the twentieth century.

The above interesting photograph was taken from St Bartholomew's tower *c*.1900, although precise dating is difficult. The photograph is rather damaged, but is included because of its interest, showing how Lower Cam has developed from a rural village over the past eighty years. The area in the immediate foreground is the bottom of Cam Pitch.

*Right:*

The bottom of Cam Pitch in its current post-rural garb. With the vast housing developments of the past forty years, Cam has become much larger than Dursley in terms of population, yet despite this fact it lacks facilities that would normally be available to a community of this size. This frustration has resulted in an unfortunate 'battling' between Dursley and Cam that helps neither parish. If only the communities could work together, the 'collective muscle' of the parishes from Uley down to Slimbridge would be much greater. United we would win, divided we always lose.

*Below:*

Cam High Street, *c.*1935. The Dursley Rural District Official Guide of 1947 states that Dursley has a population of 6,000 and 'the large parish of Cam' has 2,000. Now, half a century later, the population of Dursley remains as it was while Cam has risen to 9,000.

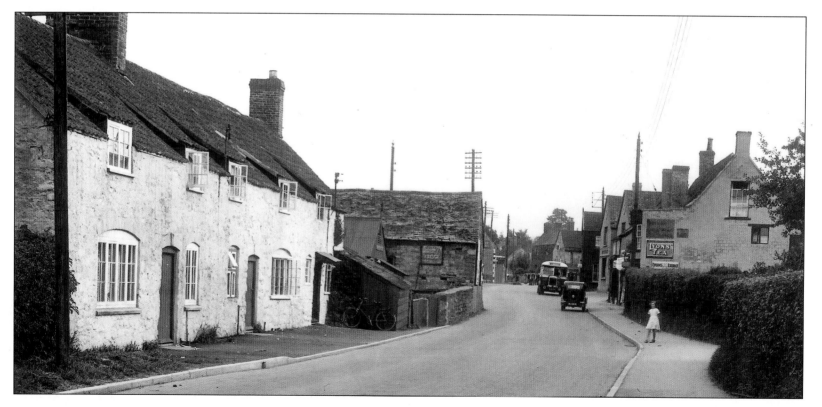

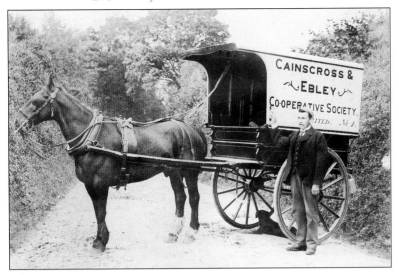

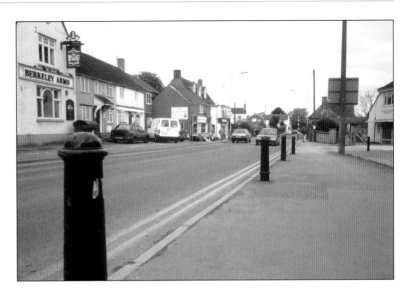

*Above:*

Cainscross and Ebley Co-operative Society van, *c.*1900. I was told by my great-uncle Arthur Hancock that this photograph was taken in Cam, but I cannot locate the exact whereabouts. I suspect that it is at the top of Cam Pitch. The driver is a relation, but it is unmarked and all those who might have known have gone to the other world.

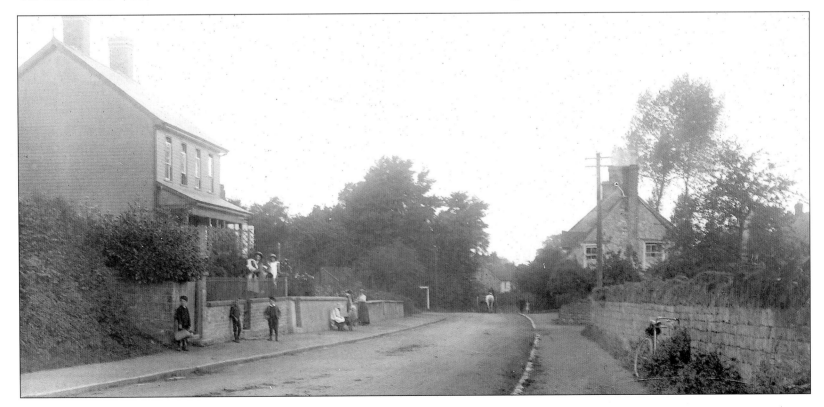

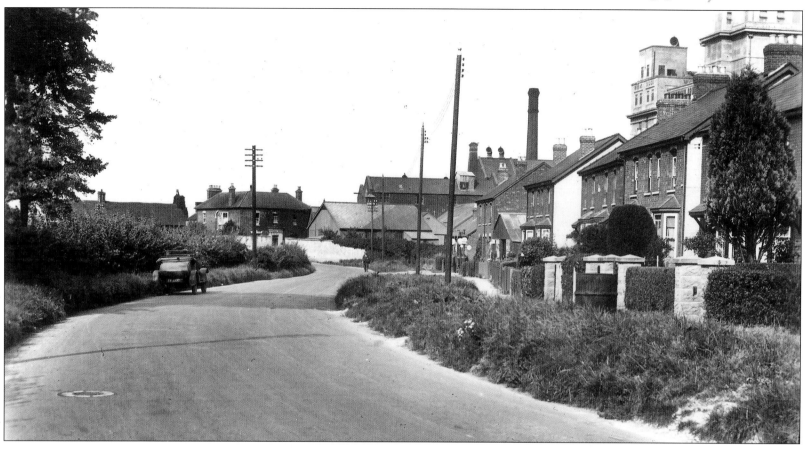

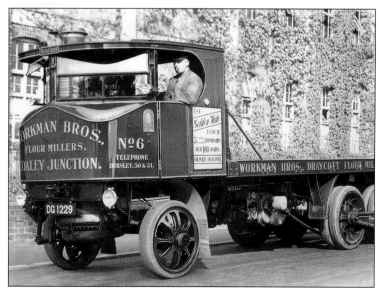

*Far left*:

Cam High Street, *c.*1910 looking towards Draycott.

*Above*:

Draycott, *c.*1930. There have been mills on this site since at least the seventeenth century, although at that time they were fulling mills for the cloth industry. In later years the mills benefited greatly from having rail access with a private siding.

*Left*:

Workman Brothers operated Draycott Mills for many years as flour mills and ran a fleet of steam lorries. The name Draycott comes from Draycott Farm, which is first recorded as early as 1248. The meaning of Draycott is quite simply a shed for a dray.

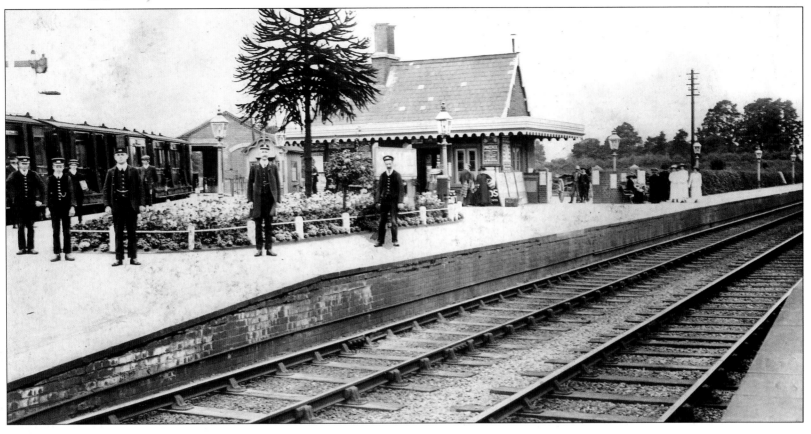

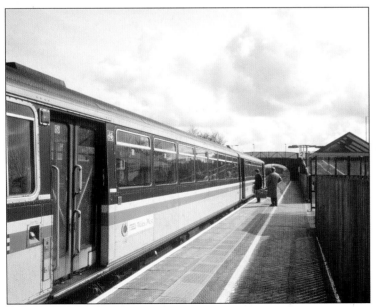

*Above:*

Coaley Junction, *c.*1900. The Dursley Donkey made the national press in February 1961 when the engine ran out of water. The train arrived at Coaley, but when it was time for the return trip, it was found to be out of water. The six waiting passengers lent a hand, forming a human chain to fill the tanks with buckets. After fifty buckets of water there was enough steam for the engine to make the trip, but in could not manage the single coach as well, so it was decided to run light to Dursley to fill up, and then come back for the coach. Three passengers were in a hurry, so the engine driver and fireman lent them black coats and pulled them up on to the footplate.

*Left:*

Cam and Dursley Station, the modern replacement for Coaley Junction.

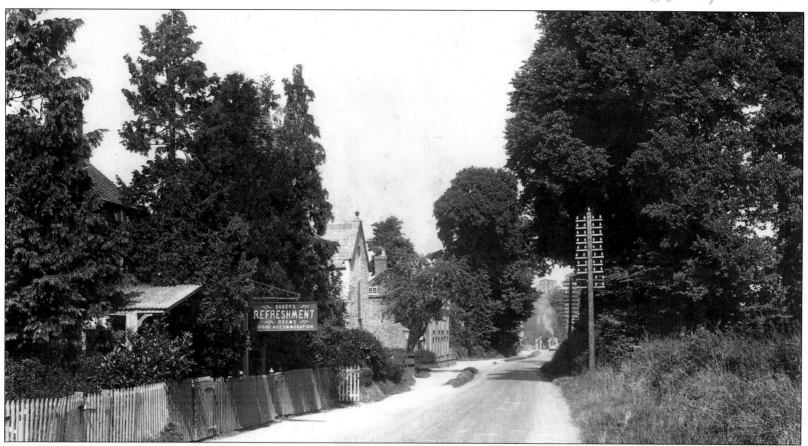

Bristol Road at Cambridge. We end our journey at the village stores (shown on the following page) – opposite from where the old Dursley Road joined the Bristol Road. This remained the junction until the motorway was built in the 1970s. Cambridge and Slimbridge, like Uley, Cam, Coaley and Stinchcombe were all satellite villages in orbit around the market town of Dursley. This changed after the War when car ownership became more common and was finally destroyed when local government reorganisation resulted in the creation of Stroud District Council. The focus has now changed, the community has changed. The market town has lost its original purpose. A new chapter will start with a new millenium.

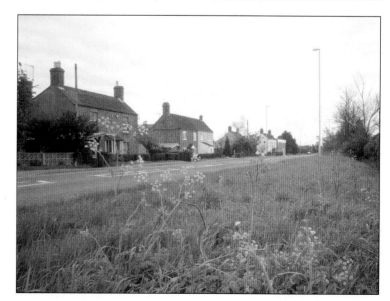

The End

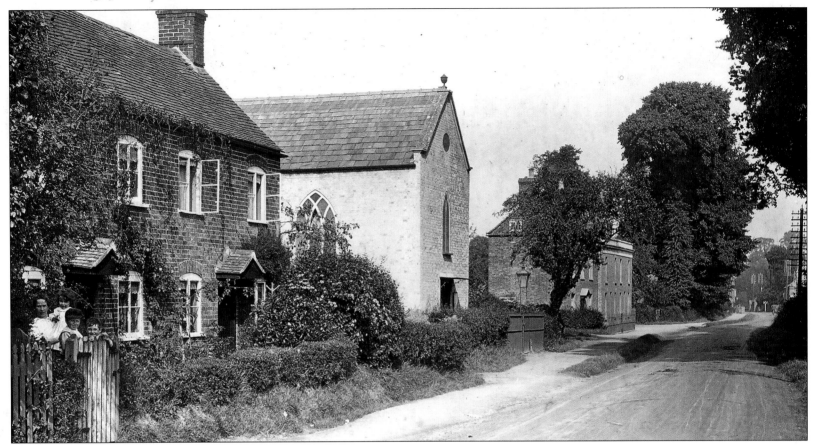

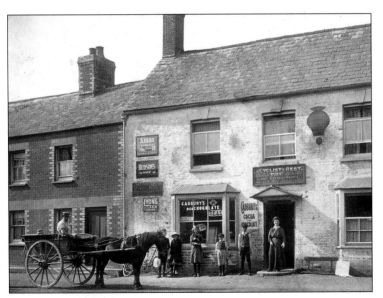

# ACKNOWLEDGEMENTS

There is insufficient space to fully thank all those Dursleyans who have given me photographs over the years, but I hope that the publication of these images, giving them a wider audience, will be thanks enough for their public spirited gifts. In particular I have to mention Matt Welsh, for without his kind help I would not have gathered together sufficient images of high quality. I also have to thank the British Museum for the photograph of the head of Mercury on page 13.